IMAGES
of America

WARWICK

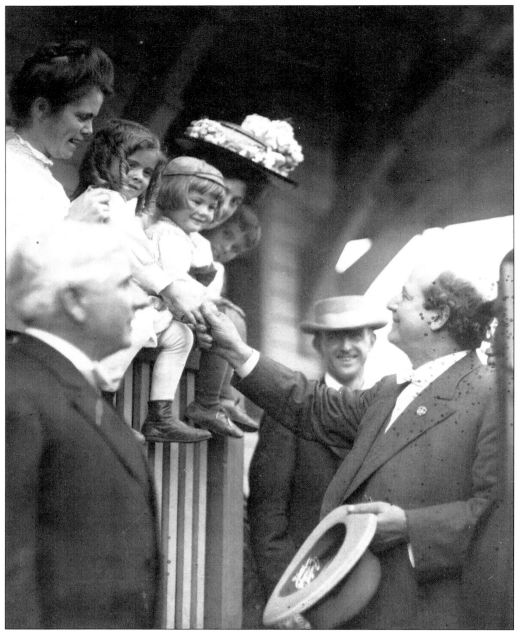

Apponaug Railroad Station in 1898. Presidential candidate William Jennings Bryan is greeted by members of the Compston family during one of his "whistle-stops" in the campaign of 1898. The station played an important role in Warwick's history as troops left from here during the Civil War and during World War I. (Dorothy Mayor Collection.)

IMAGES
of America

WARWICK

Donald A. D'Amato

ARCADIA
PUBLISHING

Published by Arcadia Publishing
Charleston SC, Chicago IL, Portsmouth NH, San Francisco CA

Printed in the United States of America

Library of Congress Catalog Card Number: Applied for

For all general information contact Arcadia Publishing at:
Telephone 843-853-2070
Fax 843-853-0044
E-mail sales@arcadiapublishing.com
For customer service and orders:
Toll-Free 1-888-313-2665

Visit us on the Internet at www.arcadiapublishing.com

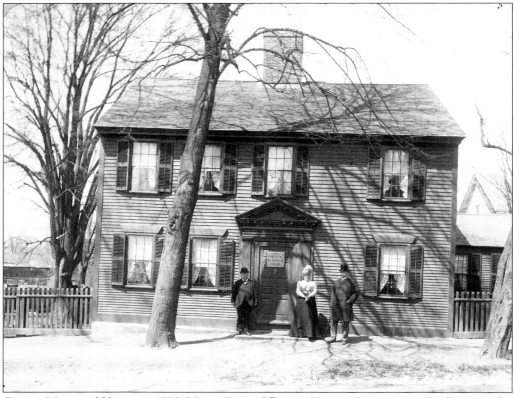

Greene Memorial House, c. 1900. Major General Francis Vinton Greene gave this house to the Rhode Island Episcopal Convention. His intention was to have it maintained as a memorial to his illustrious father, General George Sears Greene. In recent times this house at 15 Centerville Road has been owned by the Red Cross. It is now the property of Russell Howard. (Dorothy Mayor Collection.)

CONTENTS

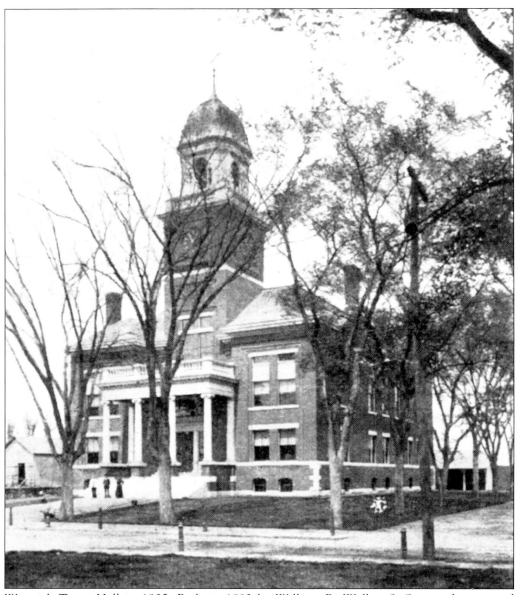

Warwick Town Hall in 1905. Built in 1893 by William R. Walker & Son, and renovated and redecorated in the 1980s, this structure remains the most significant public building in Warwick. The Pickles Bakery garage (now demolished) can be seen at the left side of the picture. Note: there is no statue in front of the town hall as this pre-dates World War I. (Dorothy Mayor Collection.)

INTRODUCTION

Warwick is a special place. It is a pleasant mixture of past and present that enchants visitors and residents alike. This city of 85,000 has no skyscrapers or old downtown as it went from a rural area to a bedroom community in the mid-twentieth century. After it became a city in 1931, critics scoffed saying, "A city? Bah! You can't even buy a suit of clothes there."

Today, thanks to the meeting of Routes I 95 and I 295 as well as some intelligent planning, Warwick is the retail capital of the state. It also houses Rhode Island's major airport and has a fast growing industrial complex.

Its history, from its founding to the present time, has reflected the major trends in Rhode Island while developing a pattern that makes it unique. As a mill village, as a suburban community, and now as a retail center, Warwick has been close to, or in, the center of major events for over three hundred and fifty years.

The colony of Warwick was founded by Samuel Gorton in 1642–43 amidst religious controversy, personal enmity, political differences, and chicanery. In time trade increased and Warwick's farms began to prosper. The slow, steady progress was halted in 1675, however, with the outbreak of King Philip's War (1675–76). The town was almost totally destroyed in this horrible conflict, but most of the settlers escaped with hopes of beginning anew.

After 1677, large farms were carved out of Warwick's wilderness and sea trade increased. A fulling mill was established in Apponaug in 1696 by John Micarter and this was followed by grist and sawmills along the Pawtuxet River.

Warwick, with its very adequate harbors in Pawtuxet and Apponaug, took part in the triangular trade with the West Indies and Africa and the colony flourished. In 1732, however, laws were passed by the British government that placed a heavy tax on sugar and molasses and threatened the high profits of the trade. Soon the Rhode Island colony protested and resorted to smuggling. Warwick, with its many coves and small harbors, was ideally suited to this illegal activity. British attempts to stop the smuggling eventually led to the burning of the revenue schooner *Gaspee* off Namquid Point in Warwick on June 9, 1772.

After hostilities erupted in 1775, Warwick townsmen played a significant role in the struggle for independence. Among the most notable were General Nathanael Greene, Colonel John Waterman, Captain Sam Aborn, Captain Robert Rhodes, and Colonel Christopher Greene.

While the men served in the military, the task of keeping the farms operable was left to the women. Their role, though not heralded, was crucial in keeping food and supplies available as Warwick's agricultural products became more and more precious during the British blockade. The Post Road became the main artery of commerce, shifting the emphasis away from the coast. As a result, by the end of the century, Apponaug became the center of the town's political and economic life.

The nineteenth century saw Warwick beginning to change from the patterns of agriculture and sea trade toward a new industry—textiles. Job Greene, son of Revolutionary War hero

Christopher Greene, helped establish Rhode Island's second textile mill in Centerville, then part of western Warwick, as early as 1794.

During the first half of the nineteenth century, the mills demanded better transportation, which resulted in the New London Turnpike in 1821 and the Stonington Railroad in 1837. These helped to make Warwick much more accessible and placed the town in a key area along the main arteries of trade in New England.

By the mid-nineteenth century, the population of Warwick had more than tripled, growing from 2,532 in 1800 to 7,740 in 1850. Small villages, such as Apponaug and Pontiac, quickly adapted to the new conditions. Private homes were often expanded into rooming and boarding houses, while new housing boomed in the western section of the city.

The Civil War proved to be another turning point in the history of Warwick as it brought unimagined sufferings for some and great wealth for others. Mill owners found a new source of inexpensive labor in the French-Canadian population and unprecedented profits resulted from war contracts.

By the end of the Civil War, very wealthy individuals found Warwick an ideal place to flaunt their new riches, especially on Warwick Neck. The most ostentatious estate on the Neck was "Indian Oaks," created by Senator Nelson W. Aldrich. Not far from Aldrich's magnificent estate was the very popular Rocky Point. This fast growing amusement center was soon followed by Buttonwoods in 1870 and Oakland Beach in 1884.

By the end of the century, it became obvious that the needs, lifestyle, and problems of western Warwick and the area east of Apponaug were very different and agitation for separation began. On March 14, 1913, 8.3 square miles of territory, half the population, and almost the entire industrial base of the town was chartered as the town of West Warwick. The division emphasized Warwick's role as an agricultural community, with the needs of farmers once again occupying much of the town's business.

The trolley line, which was established in 1910, made it much easier to commute from other areas of Rhode Island and the town grew in population. The improved transportation via the trolleys and then the automobile turned the town into the summer playground of Rhode Island's middle class.

The period following World War I introduced Warwick to new problems that showed the town at a disadvantage. The great textile industry began to weaken and totter. Prohibition proved unenforceable and speakeasies and smuggling became common in the city.

In 1929, Warwick's Hillsgrove section was selected as the site for the state airport, creating a catalyst that would greatly alter the town's environment. The new facility opened on September 26, 1931.

In 1931, Warwick became Rhode Island's eleventh city. The transition from town to city was not easy in the next decades as the municipal government struggled through the poverty of the Great Depression, the devastation of the Hurricane of 1938, and the trauma of World War II. By 1965, the population had reached 77,637 and the scars of rapid expansion could be seen throughout the city. To counteract this, village associations began the long struggle to preserve some of the city's valuable architecture and beauty.

This volume is dedicated to those who have done so much to make Warwick a worthwhile place in which to work and live.

One

APPONAUG AND ITS ENVIRONS

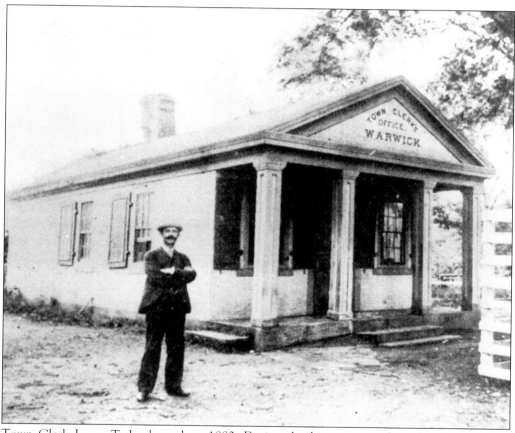

Town Clerk James T. Lockwood, c. 1880. During the late nineteenth and early twentieth centuries James T. Lockwood occupied the town clerk's office. Lockwood also taught at the old Warwick School and when Warwick built a new high school in 1927, it was named in his honor. (Ernest L. Lockwood, *Episodes in Warwick History*, 1937.)

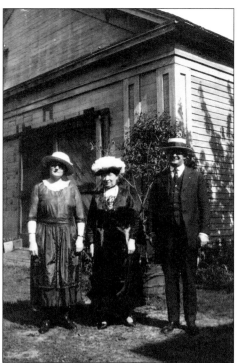

Compston Family and Old Warwick Town House, c. 1920. This building was moved from its original site to David Curtis's yard on Music Street. It served as a barn until it was torn down in the 1950s. (Dorothy Mayor Collection.)

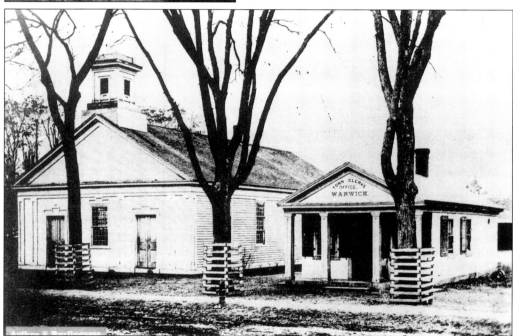

Warwick's Town Hall and Town Clerk's Office, Built 1834–35. Warwick's rural aura was evident in the necessity of putting fences around trees to keep cattle and other animals, then common on Main Street, from damaging them. These buildings were removed to make room for the new town hall in 1892. (Henry A.L. Brown Collection.)

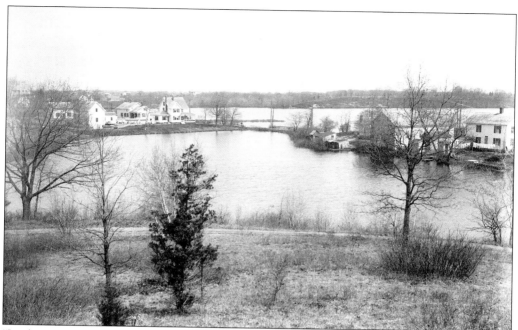

"Little Pond" and "Big Pond" (Gorton's Pond) in the 1930s. This photograph was taken from the Caleb Greene burial ground, not far from the FOP club on Tanner Avenue. The pond was instrumental in getting the Oriental Print Works to come to Apponaug in 1857. (Dorothy Mayor Collection.)

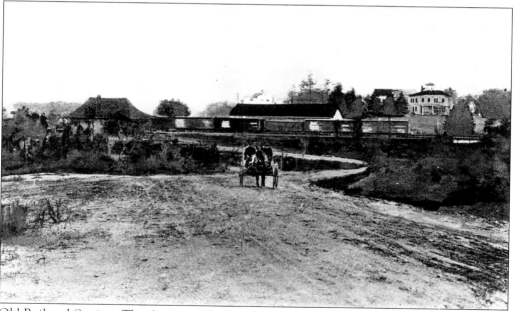

Old Railroad Station. The Apponaug Railroad station can be seen in the background of this photograph of a horse-drawn buggy traveling down West Shore Road at the intersection of Long Street. Williams Corner is to the right and the large house shown is that of Randall Harrington, who owned and managed Rocky Point. (Dorothy Mayor Collection.)

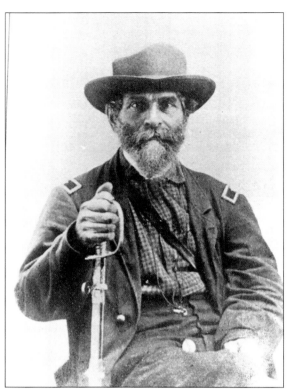

General George Sears Greene on August 9, 1862. Apponaug's sixty-one-year-old General Greene earned a reputation as a "front-line general" at Cedar Mountain and at Antietam during the Civil War. He is especially remembered for his heroic defense of Culp's Hill at Gettysburg, which saved the Union army from disaster. (Henry A.L. Brown Collection.)

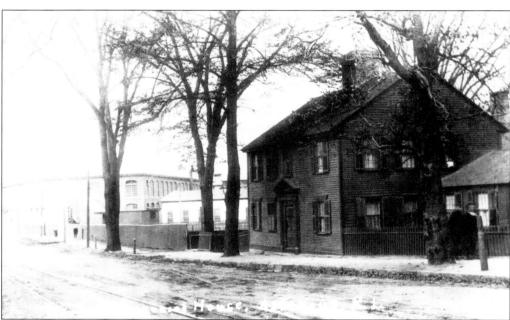

Caleb Greene House (Greene Memorial Building) and the Apponaug Company in the Early Twentieth Century. Both buildings remain on Centerville Road near the Four Corners. The mill was devastated by fire in 1961 and 1966. (Henry A.L. Brown Collection.)

The Kentish Artillery Armory, Erected 1854, Replaced 1912. The first wooden armory was destroyed in the devastating fire of 1911. It was replaced by the present brick building in the following year by William R. Walker & Son, the architects of the 1893 Town Hall. (Dorothy Mayor Collection.)

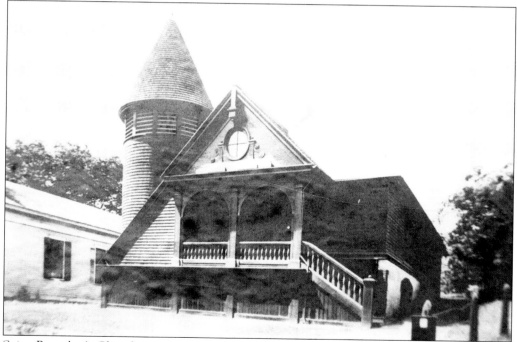

Saint Barnabas's Church, c. 1900. This handsome wooden structure was totally destroyed by the 1911 fire in Apponaug. Unlike the armory that was quickly replaced, Saint Barnabas's was not rebuilt until 1926. The stone structure built then still stands today. (Warwick Historical Society Collection.)

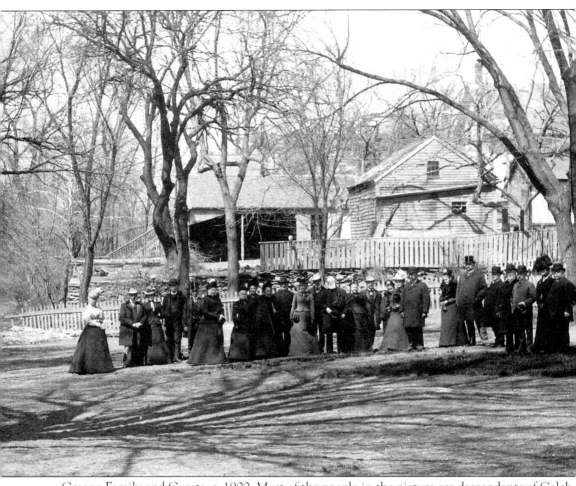

Greene Family and Guests, c. 1900. Most of the people in the picture are descendants of Caleb Greene, the merchant who built the house which still stands on Centreville Road near the Four Corners. The structure is known today as the Greene Memorial House. The group is standing near a brook which runs from Tollgate Road to Greenwich Avenue. The house, barn, and garage in the background belonged to Mary Greene. These structures, which no longer exist, would have been located between People's Storage and Robert Barrad's house. (Dorothy Mayor Collection.)

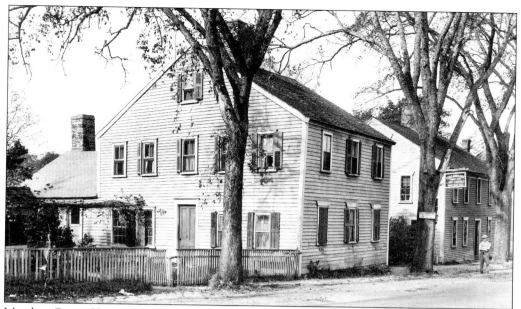

Meadow Street Houses in 1920. These homes were on Post Road in Apponaug, south of the bridge at the west end of the cove. Meadow Street entered Post Road between the first two houses. The sign says: "Cedar Brook Farm — Light Lunches — Home Made Pies." (Dorothy Mayor Collection.)

Wilbur Store (Built 1798) and I.M. Gan's Second Store, 1920s. Looking toward East Greenwich, this building was near the corner of Water Street and Post Road, close to the site occupied by a doughnut shop today. Music Lane is behind the building. Gan had this store before he moved to the Four Corners. (Dorothy Mayor Collection.)

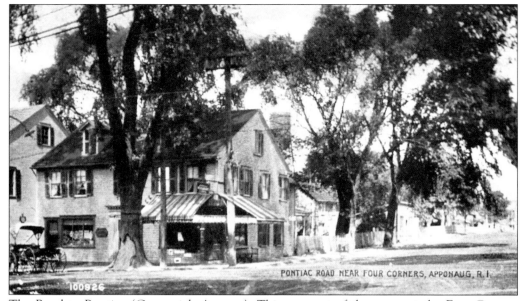

The Road to Pontiac (Greenwich Avenue). This was part of the scene at the Four Corners at the turn of the century. The dirt road on the right led to the thriving village of Pontiac. (Dorothy Mayor Collection.)

Old Saint Catherine's Church in 1880. This church was constructed on Pontiac Road (now Greenwich Avenue) after 1873, when Catholics were numerous enough to finance this 24-by-60-foot building. It was replaced by the present church on Post Road in 1919. (Dorothy Mayor Collection.)

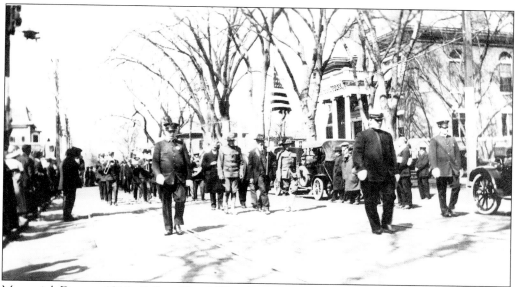

Memorial Day, c. 1918. Police Chief Ellis A. Cranston leads a Memorial Day parade past the town hall. Cranston was the chief when the force became permanent in 1921. (Dorothy Mayor Collection.)

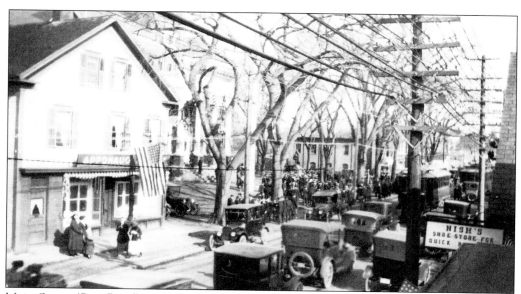

Main Street (Post Road) in 1918. The large building on the left is the Sam Pickles building. Once the Pickles Bakery, at present it is the Apponaug Printing Company. Note: across from the bakery was Nish's Shoe Store. (Dorothy Mayor Collection.)

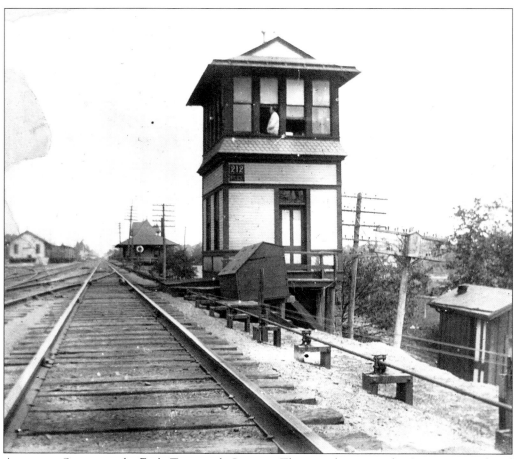

Apponaug Station in the Early Twentieth Century. This signal tower at the Apponaug Railroad Station was a busy place when trains running between New York and Boston made regular stops in Apponaug. During World War I, a temporary encampment was set up in this freight yard. (Dorothy Mayor Collection.)

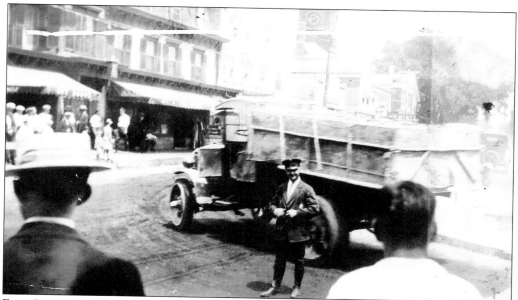

Four Corners Traffic, c. 1919. Albert Izzi, a special constable in 1919 and later a member of Warwick's small permanent police department, directs traffic at the Four Corners. The force had no standard uniforms in this early period and Officer Izzi is wearing the uniform he used when he played saxophone with the Natick band. Note the hotel and the Gilbert building in the background. (Marie Izzi Collection.)

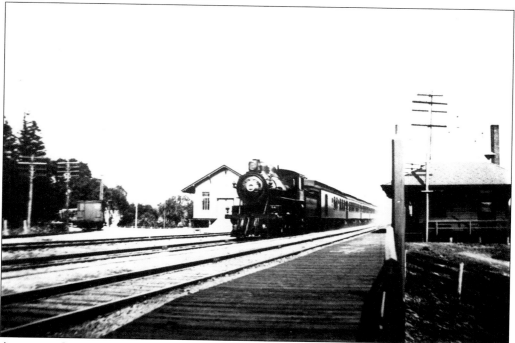

Apponaug Station, c. 1900. The railroad played a key role in the development of Warwick. It transported goods and workers and was a vital link with the rest of New England. (Warwick Historical Society Collection.)

Apponaug in 1919, Looking East on Main Street. The Gilbert building next to the hotel housed a drug store at the time. This was during the era of the trolley car. (Bob Champagne Collection.)

Post Road in 1919. Ed Swan's A & P can be seen on the left, in this view looking south from the Four Corners. (Bob Champagne Collection.)

Apponaug Fire Station, c. 1920. The firehouse was built in 1898 and was occupied by the Apponaug Fire District until 1949. It was used by the Boy Scouts, the Fraternal Order of Police, and the Warwick Municipal Employees Credit Union before being demolished. (Donald Skuce Collection.)

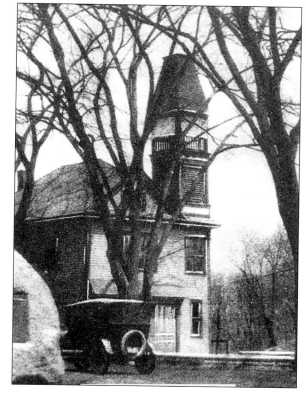

Apponaug's Last Volunteer Fire Company, c. 1951. The group poses before their recently-built station at 140 Veterans Memorial Drive. The firehouse is now Station #1 and the headquarters of the Warwick Fire Department. (Charles Pendergast Collection.)

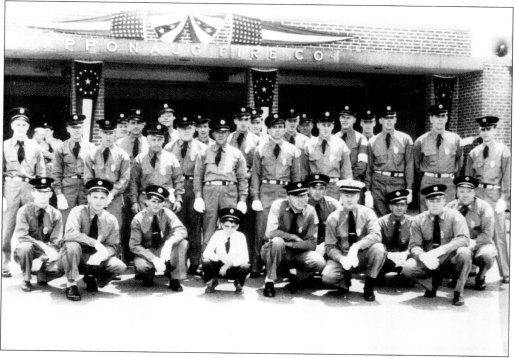

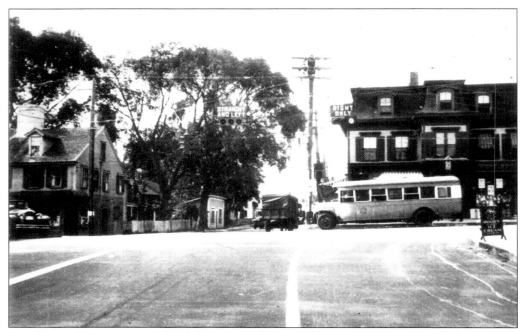

The "Green Hornet" Bus in 1927. The bus is shown waiting near the Apponaug Hotel, across the street from a shoe store (now a drug store). Next to the store was Joe Perkins's barn. People's Storage now occupies that site. (Charles Arthur Moore III Collection.)

Workmen on Main Street, c. 1927. These men are working in front of Smith's Store on the corner of Main Street and the Pontiac Road (Greenwich Avenue). Further up the avenue is the Arnold building, then George Harrop's house. (Charles Arthur Moore III Collection.)

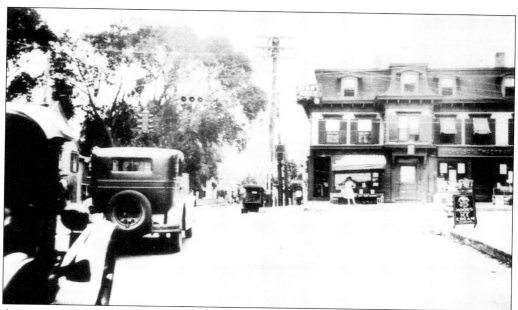

Apponaug Four Corners, c. 1927. The stores fronting the Apponaug Hotel included a tailor shop and a dry goods store. (Charles Arthur Moore III Collection.)

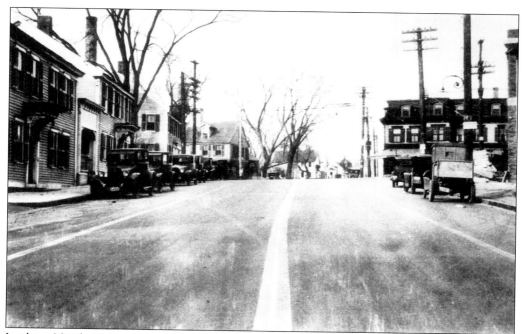

Looking North in Apponaug from Jordan's Fish Market. The three buildings on the left have been demolished. The site of the building at the top left is now occupied by the Warwick Prescription Center. (Charles Arthur Moore III Collection.)

Apponaug, *c.* 1927. Neb Smith's barber shop and the old A & P once stood where I.M. Gan's parking lot is now. The Apponaug Hotel was across the street from the A & P. During the rapid growth of Warwick after World War II, the Four Corners changed drastically. The Apponaug Hotel was demolished and a Shell gas station occupies the site at the present time. (Charles Arthur Moore III Collection.)

Saint Catherine's Church Construction in 1917. The crowd is gathered for the laying of the cornerstone for St. Catherine's Catholic Church on August 19, 1917. Construction of the church was delayed because of World War I. It was completed in 1919. (Bob Champagne Collection.)

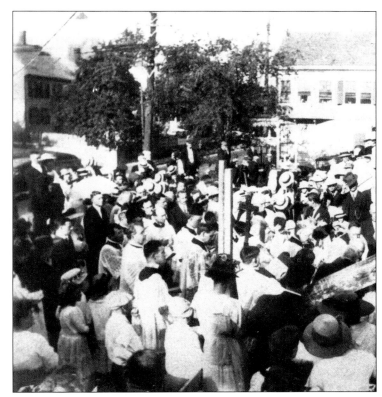

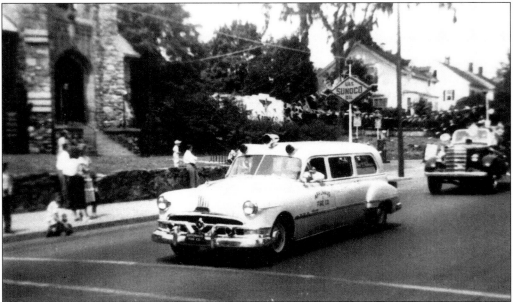

Fourth of July Parade in 1954. The parade through Apponaug, led by an Apponaug Fire Company vehicle, passed by Tyrus's gas station (now Dorothy Mayor Park) and Saint Barnabas's Church en route to the Four Corners. Two-way traffic was allowed at that time. (Bob Champagne Collection.)

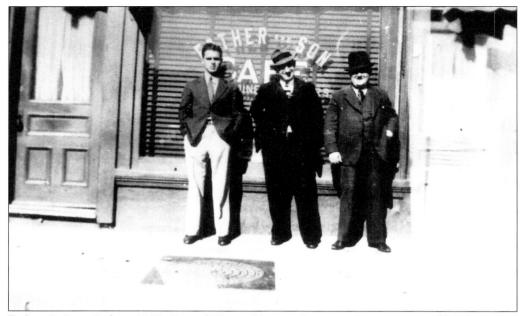

Father & Sons Cafe in 1937. One of Warwick's most famous cafes was operated by the Coutu family. From left to right are: Paul Coutu, Henry Moorehead, and Wilbrod Coutu. (Bruce Eastman/Bob Champagne Collection.)

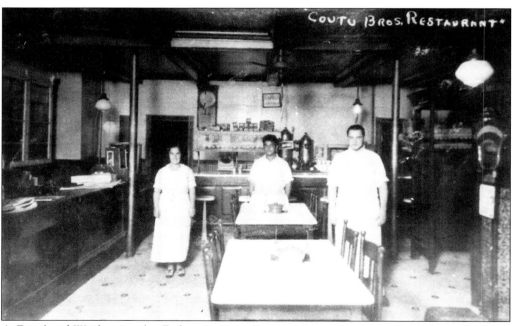

A Family of Workers at the Father & Sons. Beatrice Coutu Eastman, Pete Coutu (center), and Felix "Buzz" Coutu at work in the kitchen of the Father & Sons Cafe in the 1930s. (Bruce Eastman/Bob Champagne Collection.)

Main Street, Apponaug, in 1935. This Austin was used to advertise for the Father & Sons Cafe. It was owned by Felix Coutu, who also owned the Father & Sons. (Bruce Eastman/ Bob Champagne Collection.)

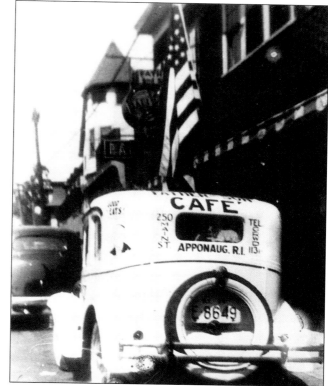

Main Street, c. 1930s. A summer parade stops in front of the old Richmond house across from Saint Catherine's Church. The house was replaced by Tyrus's gas station and the site is part of the Dorothy Mayor Park. (Bob Champagne Collection).

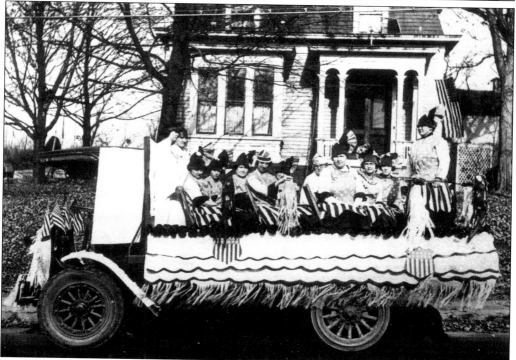

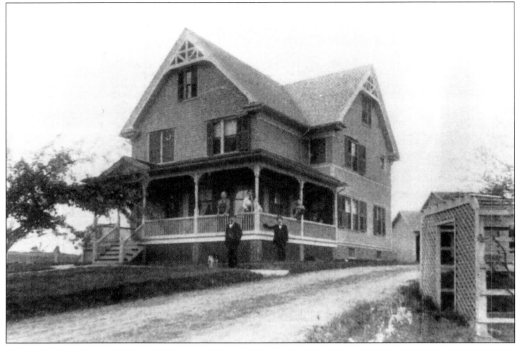

Captain John H. Northrup Residence on Tollgate Road. Captain Northrup (1841–1915) served in the navy during the Civil War and later became the supplier of shellfish to Rocky Point, a position he maintained for forty-one years. He also served as the state representative from Warwick. (Donald Skuce Collection.)

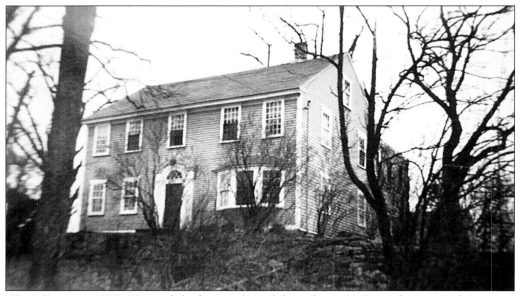

Glus's Dairy in 1917. Warwick had a number of dairy farms in the early twentieth century. Glus's Dairy was located on Tollgate Road. (Warwick Historical Society Collection.)

City Workers in 1944. Included on the steps of the Apponaug City Hall are Mabel Del Ponte (first on the right), Pearl Gallaway (the school department secretary), and Tillie Petrarca. (Mabel A. Del Ponte Collection.)

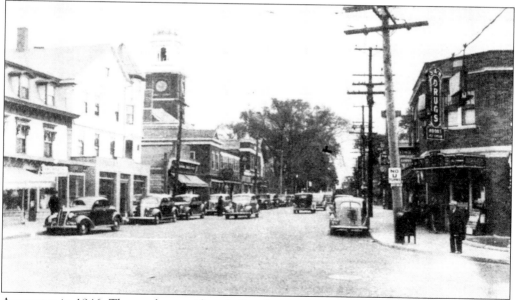

Apponaug in 1946. The road was widened after the street car tracks were removed. Part of the hotel is shown here as well as the Gilbert building. There was also a Mayflower store (later First National), a bank, Maxine's clothing store, and a hardware store. (Dorothy Mayor Collection.)

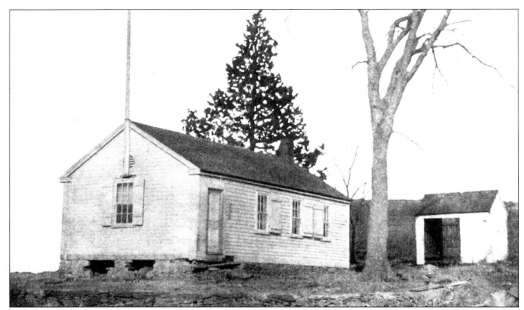

Original Central School in 1843. Schools have always played a significant role in Warwick's history. The Rhode Island School Act of 1828 and State Commissioner Henry Barnard spurred more activity in building schools in the nineteenth century. (Thomas E. Greene Collection.)

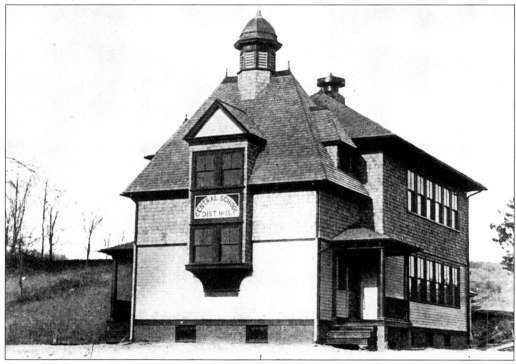

Central School in 1903. The twentieth century brought renewed efforts to update Warwick's schools. This handsome building that once stood on Centerville Road was one result. (Thomas E. Greene Collection.)

Apponaug in the Early 1950s. While the principal buildings remain, a number of changes have been made in Apponaug since the end of World War II. The old Vigilant Fire Station is gone and the area behind it, once a swamp, has been made into the Mayor John O'Brien Park. Tyrus's Sunoco gas station is gone and now the Dorothy Mayor Park adds beauty to the area. In this photograph, the city hall annex was only one-story high and there was two-way traffic on the main road through the village. (Bob Champagne Collection.)

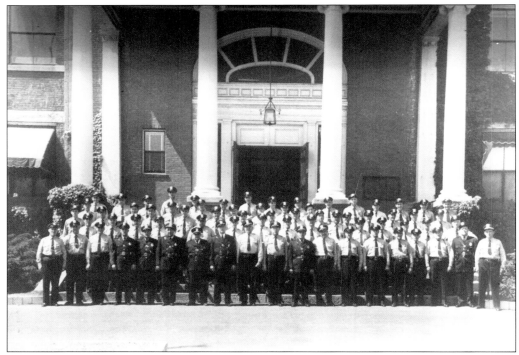

Warwick Police Force in 1950. The police department gained both manpower and a sense of professionalism in the period following World War II. The force shed its small-town image under the leadership of Chief Forrest Sprague (first row, sixth from left). (Michael Lynch Collection.)

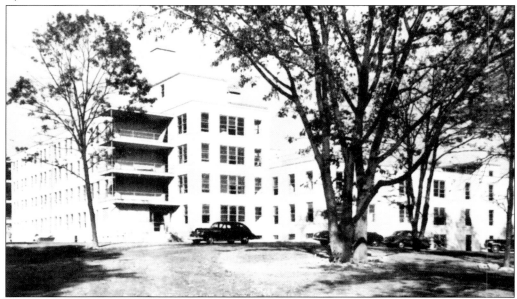

Kent County Memorial Hospital in 1951. The hospital had but ninety beds in the early 1950s, but a lot of hope for the future. Its first patient on May 1, 1951, was a frightened eight-year-old child with an umbilical hernia. (Henry A.L. Brown Collection.)

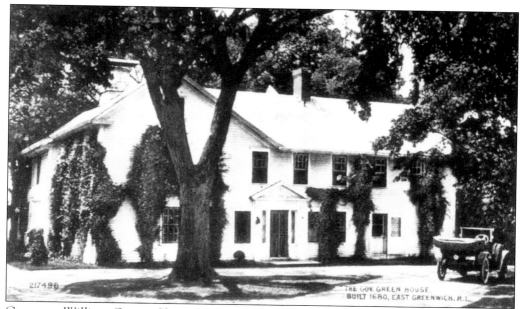

Governor William Greene House, c. 1900. Built by Samuel Gorton Jr., this was the home of Rhode Island Governor William Greene (1743–1758) and his son Governor William Greene Jr. (1778–1786). (Henry A.L. Brown Collection).

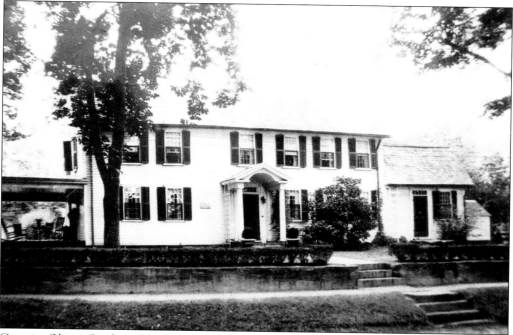

Captain Oliver Gardiner House. Built in 1750, this dwelling on Post Road in the Cowesett section was once the center of a large farm. During the Revolutionary War, Captain Gardiner was the commander of a "Row Galley" that patrolled Warwick's shore. (Ernest L. Lockwood, *Episodes in Warwick History*, 1937).

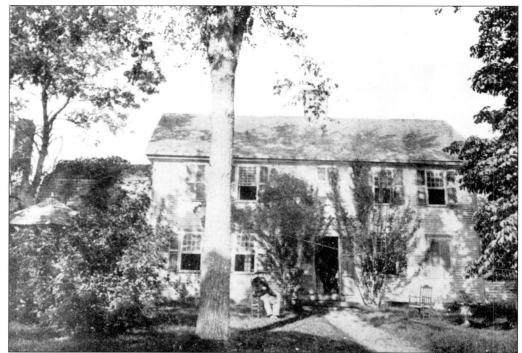

Nathanael Greene's Birthplace in the Mid-Nineteenth Century. Warwick's famous Revolutionary War hero was born here in 1742. The elderly gentleman sitting in front of the house is Judge Richard Ward Greene, who died in 1875. (Rhode Island General Assembly report, *Remains of General Nathanael Greene*, 1903.)

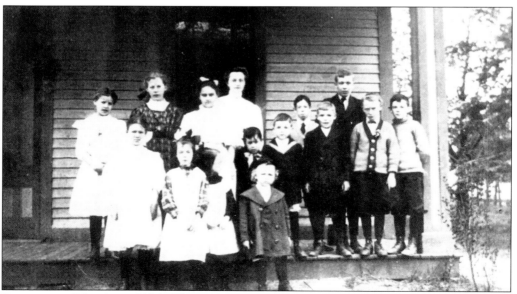

Potowomut School, *c.* 1906. This one-room schoolhouse was built in 1859. The young Potowomut scholars are under the guidance of their teacher, Anna Mathewson, who taught all grades from 1906 to 1909. (Thomas E. Greene Collection.)

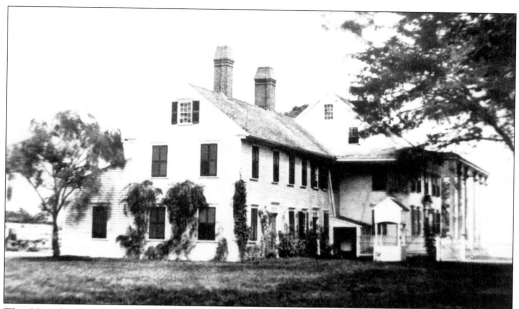

The Hopelands Mansion at Potowomut. Built by Thomas Greene in 1686, for many years it was the home of the notorious Tory, Richard Greene. Hope Brown and Thomas Poynton Ives received the house as a wedding present in 1792. The Rocky Hill Country Day School acquired the building and property in 1948. (Ernest L. Lockwood, *Episodes in Warwick History*, 1937.)

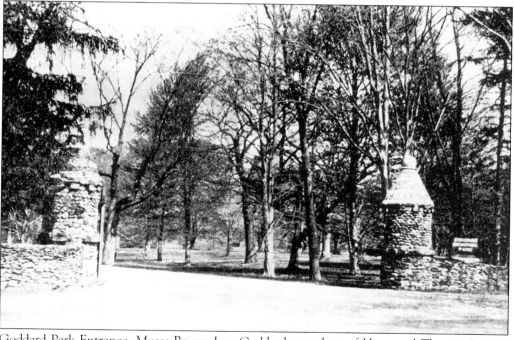

Goddard Park Entrance. Moses Brown Ives Goddard, grandson of Hope and Thomas P. Ives, inherited the 120-acre estate at Hopelands in 1881. His niece, Charlotte Ives Goddard Shaw, left this section of the estate for the residents of Rhode Island. (Henry A.L. Brown Collection.)

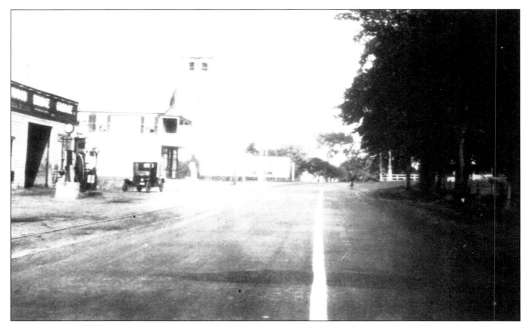

Post Road in Greenwood, c. 1927. The Greenwood Bridge Garage is shown at the left. Next to it, at the corner of Post Road and Main Avenue, is the house once owned by Francis McCabe. The Greenwood Credit Union now occupies the site. (Charles Arthur Moore III Collection.)

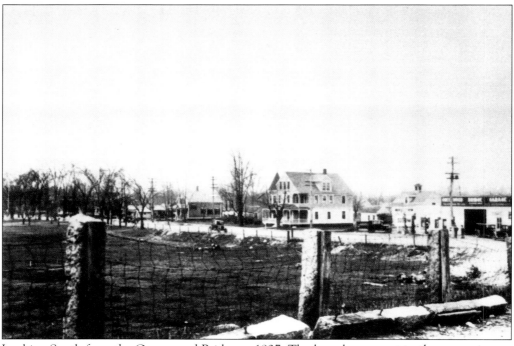

Looking South from the Greenwood Bridge, c. 1927. The large house next to the garage is now the site of Dan's Convenience Store. (Charles Arthur Moore III Collection.)

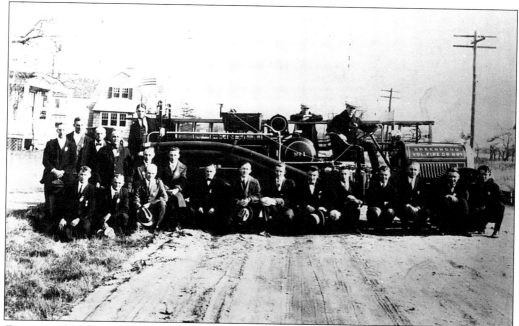

Greenwood Volunteer Fire Company #1. The company is shown here on Armistice Day in 1925. This was when Main Avenue in Greenwood was still a dirt road. (Greenwood Volunteer Fire Company #1 Museum Collection.)

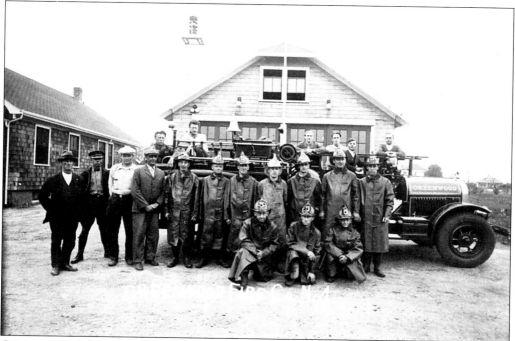

Greenwood Volunteer Firefighters. The group is shown here at their new station on Kernick Street. This is now the Fire Museum. (Greenwood Volunteer Fire Company #1 Museum Collection.)

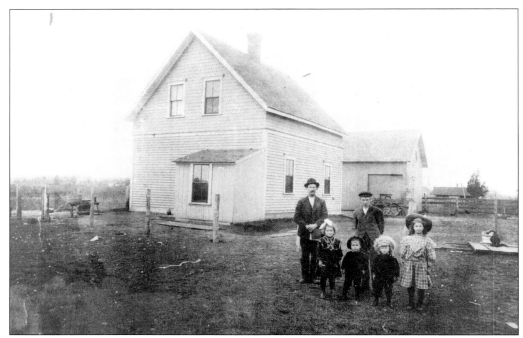

The Smith Family Home in Greenwood. Once 103 Pontiac Avenue, the address of this structure has since changed to 680 Main Avenue. From left to right are: (front row) Edith, twins Herbert and Harold, and Hazel; (back row) Herbert and his son Walter. Harold Smith was later deputy chief of the Warwick Fire Department. (Dave Matteson Collection.)

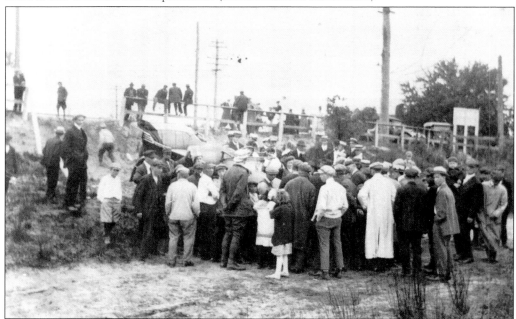

Smash! Accidents involving motor vehicles in 1915 always drew a large crowd. H.H. Rogers Jr. managed to catch the action of this one at the Greenwood Bridge. (Dave Matteson Collection.)

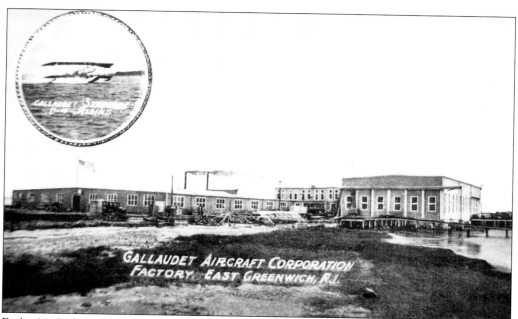

Early Air Industry. At the beginning of the twentieth century, airplanes were manufactured at Chepiwanoxet Point in Cowesett by the Gallaudet Aircraft Corporation. (Henry A.L. Brown Collection.)

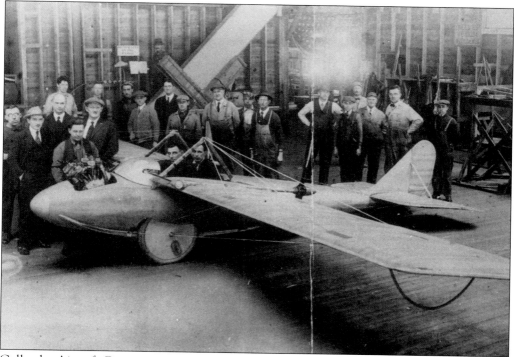

Gallaudet Aircraft Corporation, Interior. This view of the inside of the plant was taken during World War I. The signs in the background read "Do not spit on the Floor" and "Speed up—we must win the war." (Peterson Family Collection.)

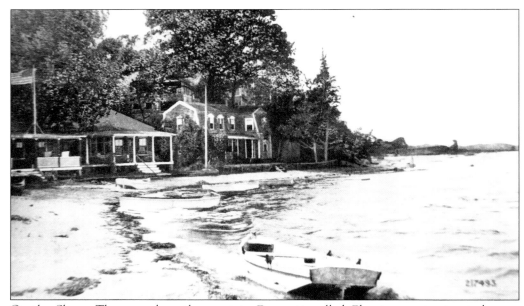

On the Shore. The area along the coast in Cowesett, called Chepiwanoxet, attracted many summer residents. Trains stopped here and the number of summer cottages grew rapidly. (Ralph Cook Collection.)

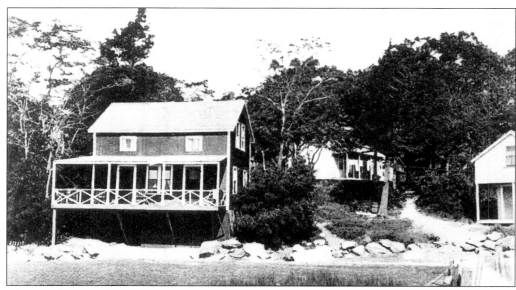

The Landing at Chepiwanoxet. A hotel accommodated much of the summer crowd. By mid-century, many of the cottages here became permanent residences. (Ralph Cook Collection.)

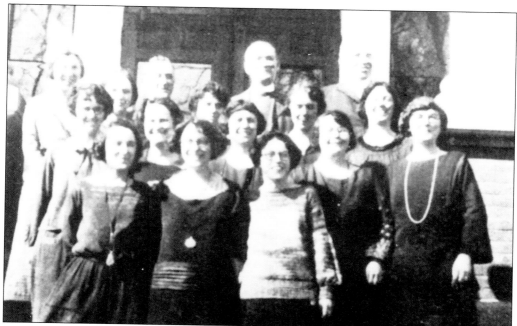

The Warwick High School Faculty in 1924. This cheerful group faced some difficult days when their school burned on February 23, 1923. They were assigned to teach classes in various buildings in Apponaug. (Henry A.L. Brown Collection.)

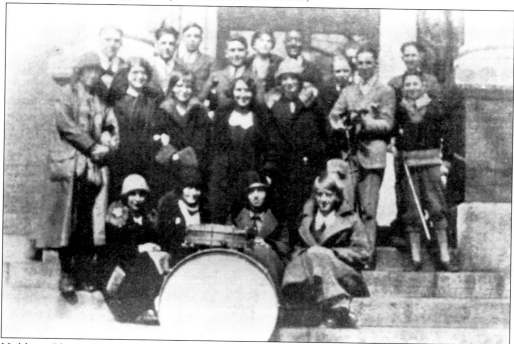

Holding Classes in City Hall. One of the nicer aspects of having the Warwick High School use city hall for classes after the 1923 fire was that on every Wednesday afternoon, the school orchestra was there. (Henry A.L. Brown Collection.)

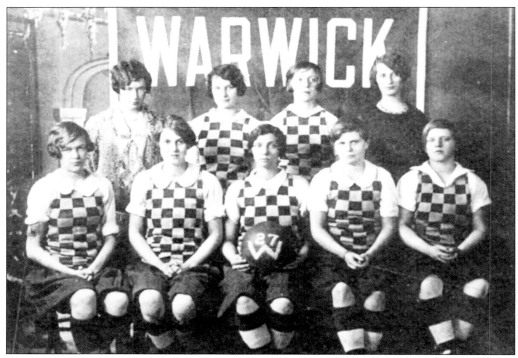

The Warwick High School Girl's Basketball Team in 1927. The team included Carolyn Harris, Dorothy Compston, Lois Wells, Ruth Shailer, Elizabeth Wright, Marion Johnson, Dorothy Hamilton, and Martha Phillips. This team won the state championship. Dot Compston scored the most points in the nation that year. (Henry A.L. Brown Collection.)

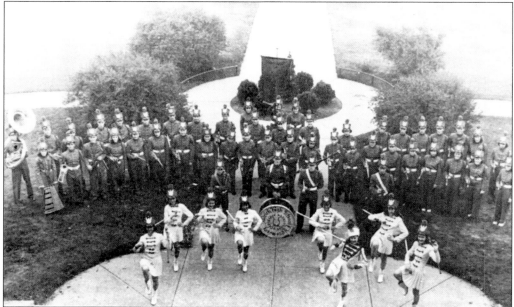

The Senior Band. Lockwood's sixty-member senior band enjoyed outstanding success in the late 1940s. (Dorothy Mayor Collection.)

Two

Historic
Pawtuxet-Spring
Green Area

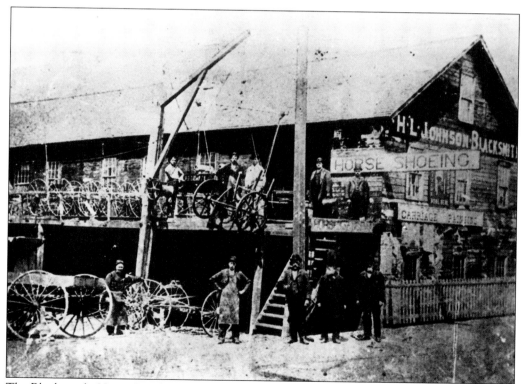

The Blacksmith. Henry L. Johnson's blacksmith shop did a brisk trade in Pawtuxet in the 1890s. Hunter's Garage is now on the site. (Henry A.L. Brown Collection.)

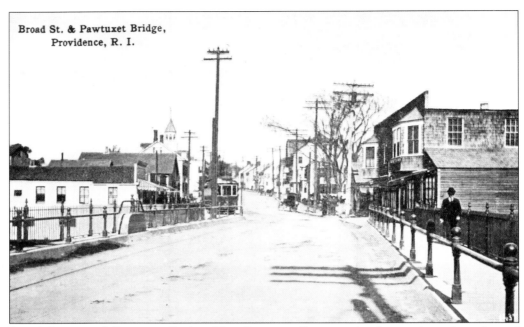

Broad Street and Pawtuxet Bridge. The Pawtuxet River marks the northern boundary of Warwick. Over the centuries there have been a number of bridges connecting the Cranston and Warwick sections of Pawtuxet. (Henry A.L. Brown Collection.)

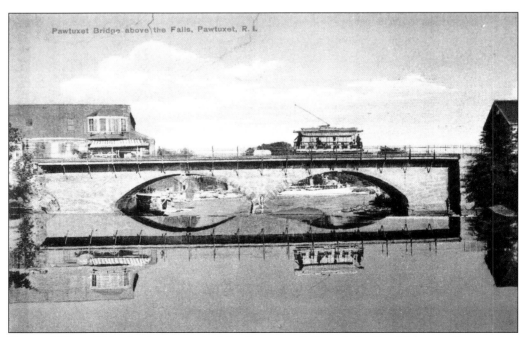

Postcard View. This classic postcard of the Pawtuxet Falls and the Bumblebee trolley crossing the bridge was a popular one to send to friends and relatives in the period shortly before World War I. (Henry A.L. Brown Collection.)

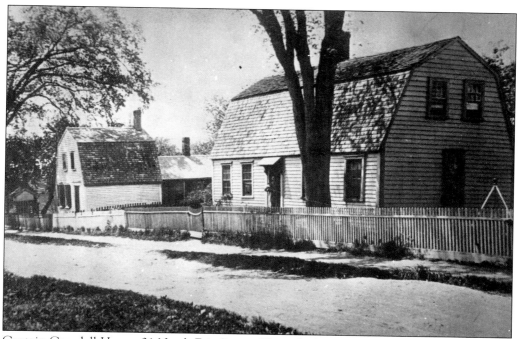

Captain Crandall House, 31 North Fair Street. The right-hand side of this charming, gambrel-roofed dwelling, one of the oldest houses in Warwick, was taken by barge from Prudence Island, c. 1690. Much of the rest of the eight-room dwelling was added during the eighteenth century. Pawtuxet residents refer to the structure as the "hollyhock house." (Susan Totten Currie Collection.)

Village Charm. The Pawtuxet Boat House, overlooking the cove, reflects the charm of the old village. It was used by the naval reserve in the mid-twentieth century. (Henry A.L. Brown Collection.)

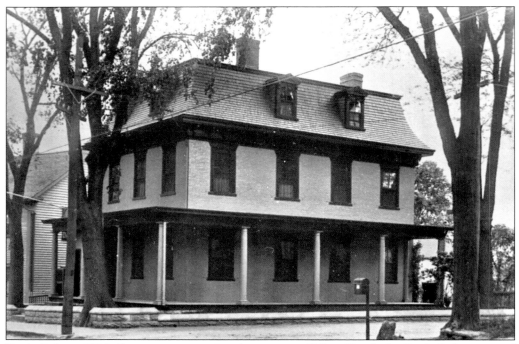

Bank Cafe, c. 1920. From its commanding location at 40 Post Road, the Bank Cafe is a vivid reminder of Warwick's rich nineteenth-century heritage. It was built in 1815 as a bank, reflecting Pawtuxet's importance as a seaport. In 1874, James Tinker established a fine restaurant in the building. It was, until it closed recently, one of the oldest eating establishments in the United States. (Annie Totten Collection.)

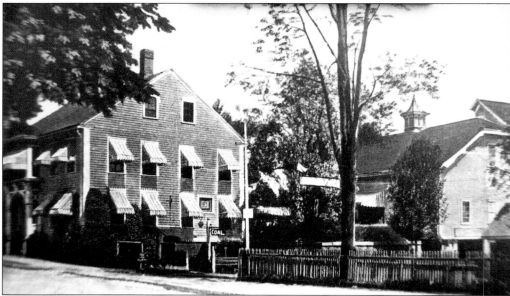

Agricultural Roots. The Joseph B. Haywood Grain Company in Pawtuxet in the early twentieth century reflects Pawtuxet's dual role as a seaport and agricultural community. (Henry A.L. Brown Collection.)

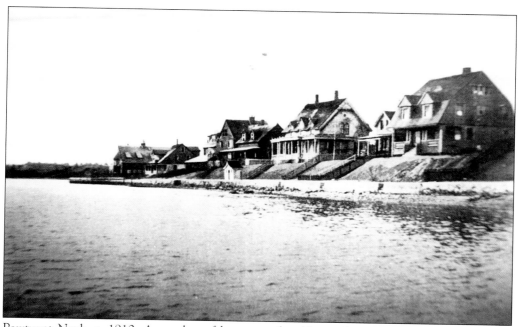

Pawtuxet Neck, c. 1910. A number of large, comfortable residences were built on Pawtuxet Neck as better transportation facilities brought more people to the area. (Henry A.L. Brown Collection.)

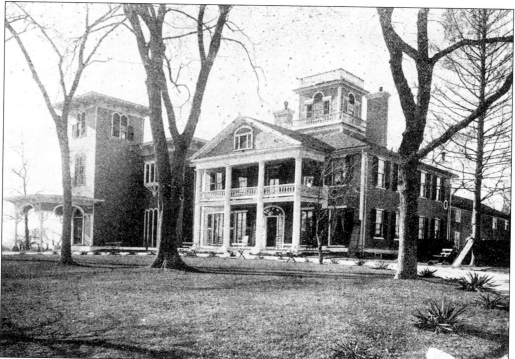

The Choppequonsett Country Club near Pawtuxet. This structure, once the home of Nicholas Brown (an ambassador to Italy) was destroyed by fire in 1888. (Henry A.L. Brown Collection.)

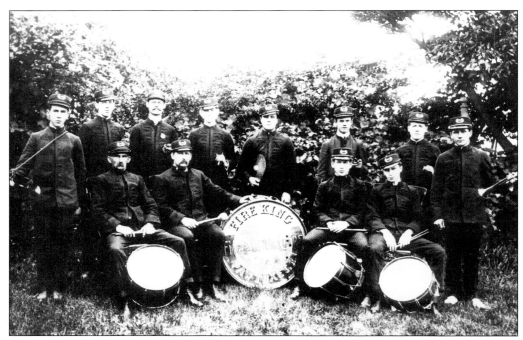

Fire King Band. The Fire King Fife and Drum Corps led the parades staged to celebrate the victories won by the Pawtuxet Volunteer Fire Company #1 at nineteenth-century musters. (Pawtuxet Volunteer Fire Company #1 Collection.)

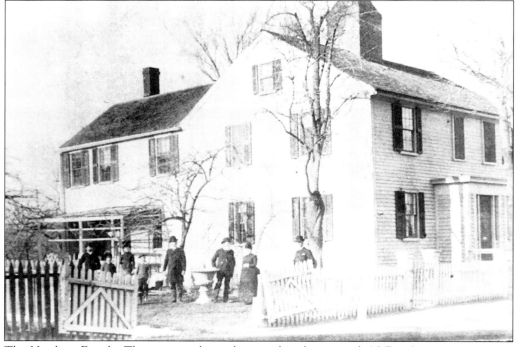

The Hawkins Family. The group is shown here at their homestead, 25 Fair Street in Pawtuxet, on Christmas Day, 1886. (Gladys Dyer Collection.)

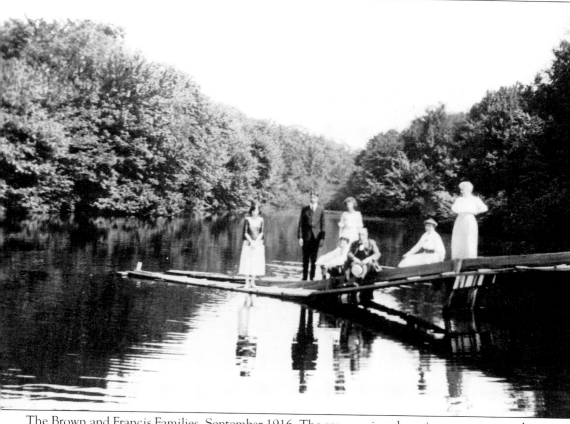

The Brown and Francis Families, September 1916. The group enjoyed a quiet moment near the "ice-run" on the pond at Spring Green. From left to right are: (front row) Arthur G. Francis, Frank Hail Brown, and Alice Francis Brown; (back row) Louise Francis, Francis Hail Brown, Maude P. Francis, and Julia Francis. The area is now part of the Governor Francis Farms section of Warwick. (Henry A.L. Brown Collection.)

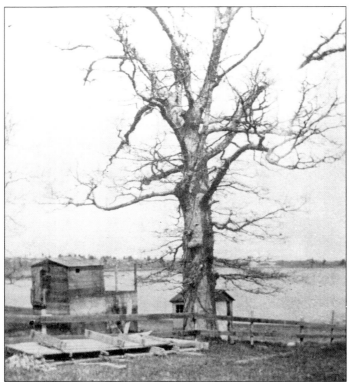

Last Boundary Oak. This old oak tree was used by surgeon John Greene in 1661 as a marker on his farm at Green's Hold (later named Spring Green by John Brown). It is the last boundary oak in Warwick, having survived many hurricanes and gales. (Henry A.L. Brown Collection.)

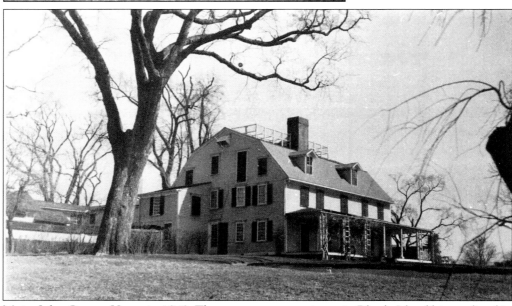

Major John Greene House in 1940. Three men very prominent in Rhode Island history lived in this lovely house which still stands at Spring Green. It was built by Major John Greene, deputy governor from 1690 to 1708. It became the summer home of merchant prince John Brown and his grandson, John Brown Francis, who was governor from 1833 to 1838 and a U. S. Senator from 1844 to 1845. (Henry A.L. Brown Collection.)

Spring Greene House Mantle in 1880. The lovely mantle dates to Tudor England. The fireback depicts the Greene family symbol, a deer. (Henry A.L. Brown Collection.)

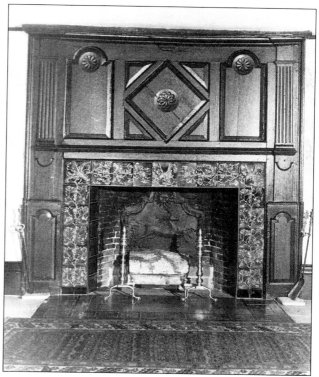

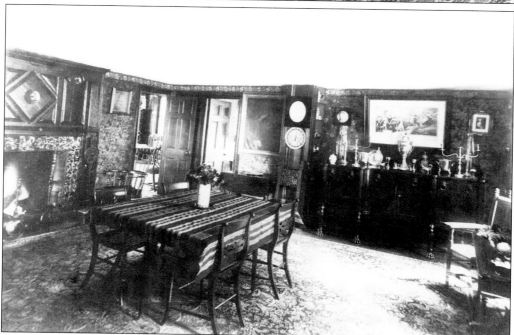

Tudor Mantle Dining Room, c. 1880. Elizabeth Francis, daughter of Governor John Brown Francis, purchased beautiful "Bird's Eye" maple chairs in Apponaug to add to the beauty of this historic room. (Henry A.L. Brown Collection.)

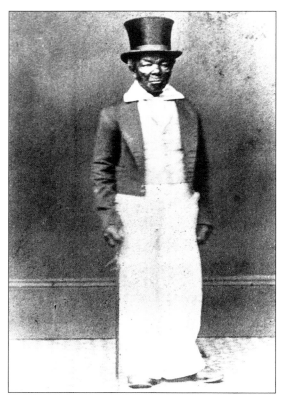

Traveling in Style. Coachman John Williams, who accompanied John Brown Francis of Spring Green on many trips, was 102 years old on April 30, 1877. In 1833, according to *Arnold's Historical Register*: "Governor Francis drove down from Providence in a coach drawn by four white horses driven by a Negro coachman." (Henry A.L. Brown Collection.)

John Brown's Chariot. The vehicle was commissioned by John Brown in 1782 and is the earliest American-built chariot in existence. George Washington rode in this chariot when he visited Providence in 1790. The chariot remained at Spring Green for many years until 1959, when it was restored and placed on exhibit at the John Brown Mansion in Providence. (Henry A.L. Brown Collection.)

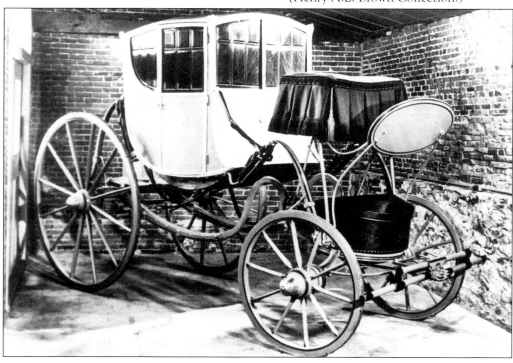

A Fashion Statement. In the nineteenth century little boys dressed much more formally than they do today. Very little boys wore dresses, as Francis Hail Brown does here. The young boy plays under the watchful eye of his Irish nanny. (Henry A.L. Brown Collection.)

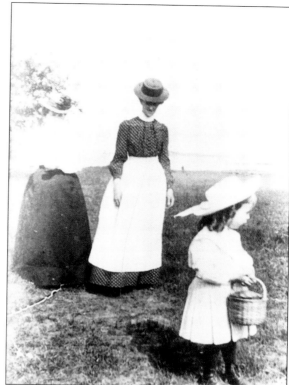

Big Brother. John Francis Brown, Francis Hail's elder sibling, was old enough to wear short pants in this photograph. John Francis holds his little brother's hand as they wander through the grounds at Spring Green. (Henry A.L. Brown Collection.)

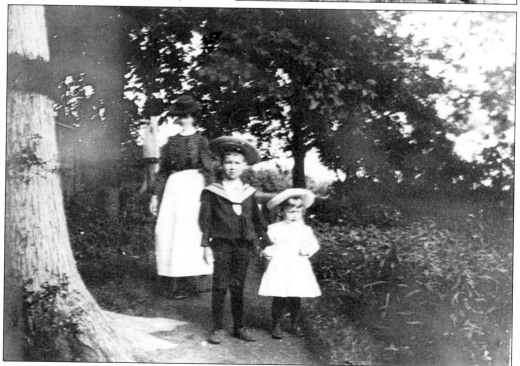

53

Taking a Stroll, c. 1902. Sally Francis, the last surviving child of Governor J.B. Francis, strolls by the greenhouse at Spring Green accompanied by young John Francis Brown. (Henry A.L. Brown Collection.)

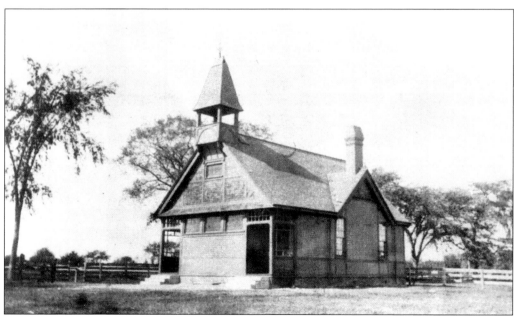

Spring Green School in 1881. Governor J.B. Francis' daughters, Elizabeth and Sally, felt it was extremely important to encourage public education. With that in mind, they built the Spring Green School. (Henry A.L. Brown Collection.)

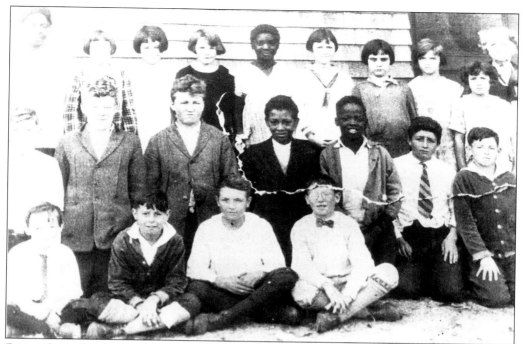

Spring Green Students. A mixture of happy and not so happy scholars gathered at the Spring Green School with their teacher, Miss Slocum, in 1923. From left to right are: (front row) Clifton Clark, Tom Quaine, George Palumbo, and Russell Clark; (middle row) Vernon Anthony, Ralph James, Ben Clark, Cliff Crayhead, Ollie Weeden, Sam Palumbo, and Billy Quaine; (back row) Ina Perry, Ruth Clark, Gloria Dunlap, Hazel Burns, Allegra Perry, Madeline Burns, Emily Gabbaliard, Florence Murphy, Jesse Palumbo, Helen Tyler, and Miss Slocum. (George Palumbo Collection.)

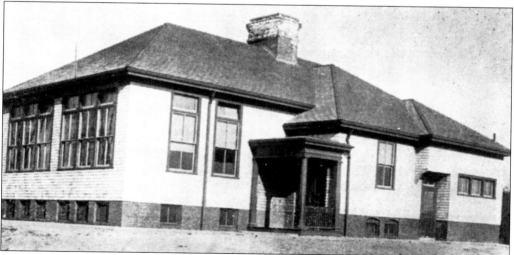

Spring Green School in 1959. In 1912, the building shown here replaced the earlier school built by the Francis family. After serving the area for many years, the school was leased by the City of Warwick for #1 to the House of Hope as a temporary shelter for displaced families. (Henry A.L. Brown Collection.)

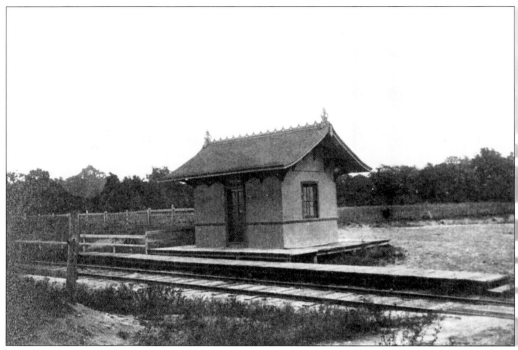

The Spring Green Station in 1889. The Francis sisters were willing to promote the Warwick Railroad and allowed for a stop at Spring Green. In 1881, the Warwick Railroad passed into the hands of the New York, Providence, and Boston line. (Henry A.L. Brown Collection.)

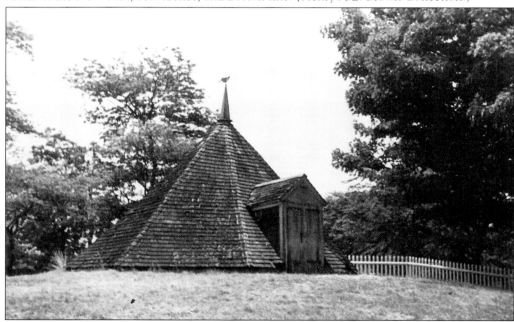

Spring Green Icehouse in 1940. This is one of the oldest of its type extant. It was ordered built by John Brown in 1786, shortly after he acquired "Greene's Hold." (Henry A.L. Brown Collection.)

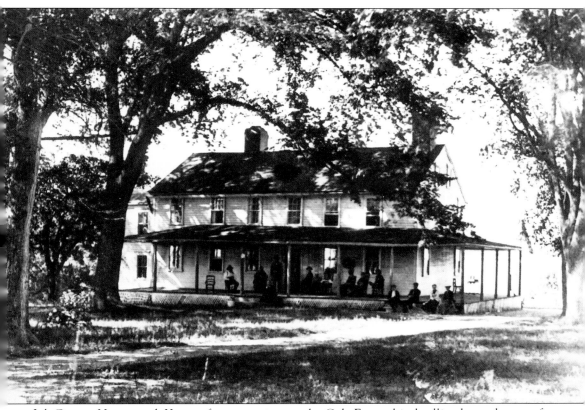

Job Greene Homestead. Known for generations as the Cole Farm, this dwelling housed some of Rhode Island's most prominent leaders. It was built by Deputy Governor John Greene Jr.'s son Job, c. 1677. Job was the "Mayor of the Main," a rank equivalent to commander of all militia units. His son, Judge Philip Greene, was a friend of Benjamin Franklin, who visited the farm on at least one occasion. Philip's son Christopher, who gained Revolutionary War fame as the hero of the Battle of Red Bank, was born here on May 12, 1737. In 1817 the house and property were sold to William Davis Cole. (Henry A.L. Brown Collection.)

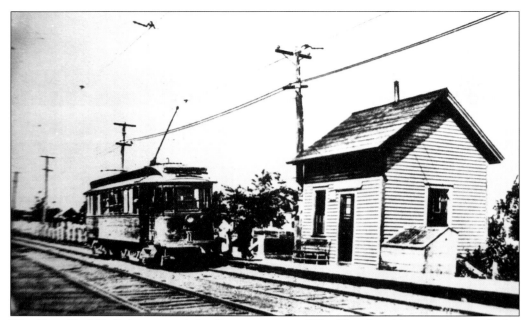

The Elms. Fred B. Cole renamed the Greene property "The Elms," and became famous for his clambakes. The trolley brought many to Cole's station to partake of the summer activities. Cole took advantage of the new transportation for his yearly trek to Apponaug to get a haircut. If the shop was closed, he waited another year. (Henry A.L. Brown Collection.)

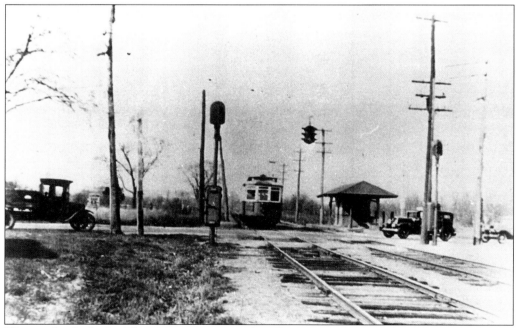

Waiting for the Light. The 1930s saw increased traffic activity in Warwick. Here, an automobile and truck stop at a red light waiting for the trolley to pass at Palace Gardens Crossing on Narragansett Parkway. (William Savasta Collection.)

Gaspee Point Beach, 1914. Long after the area became famous for the sinking of the British revenue schooner *Gaspee* on June 9, 1772, and long before the coming of the "bikini," Gaspee Point Beach attracted ladies and gentlemen from various sections of the state, who came to enjoy its cool breezes. (Henry A.L. Brown Collection.)

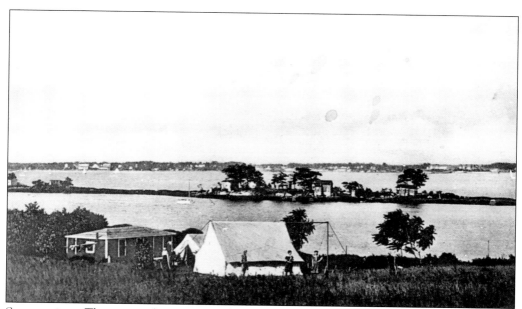

Summertime. The tents, the water, and the simple cottages on Rock Island as seen from Warwick Downs all reflect the charm of a summer in Warwick in the early twentieth century. (Miriam Smith Collection.)

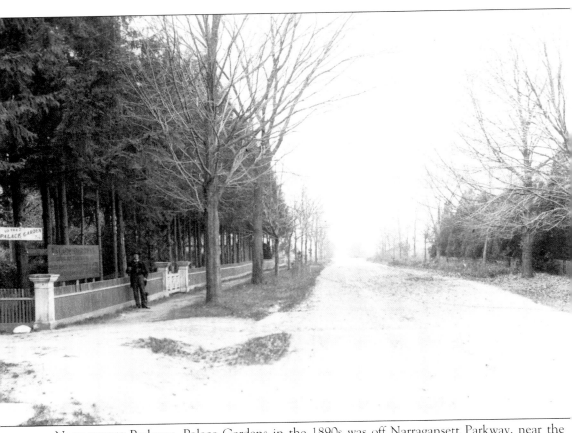

Narragansett Parkway. Palace Gardens in the 1890s was off Narragansett Parkway, near the present-day Mormon church. The parkway was just a dirt road then. Work began on the road in 1912, but for a long time it was a rough gravel road. Finally, by 1927, the road was paved and it became one of Warwick's most significant streets. (Everett Johnson Collection.)

The Cataract Fire Company of Lakewood, *c.* 1900. This company challenged all area fire companies in pumping competitions. They are shown here proudly towing their own hand pumper. (Greenwood Volunteer Fire Company #1 Museum Collection.)

Lakewood Volunteers. The Cataract Fire Company is shown here in front of Infantry Hall, located on Atlantic Avenue in Lakewood. The large group is indicative of the popularity of the fire company in the early twentieth century. The Lakewood Company was often the first to adopt advanced methods of fighting fires. (Greenwood Volunteer Fire Company #1 Museum Collection.)

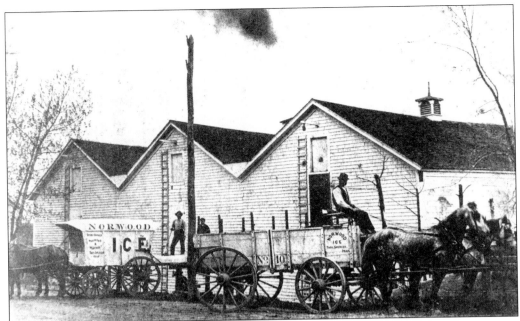

Ice Wagons. During the early twentieth century, Maurice Johnson's ice wagons were a common sight on Post Road. Most customers had very little knowledge of the hard work and danger involved in cutting, storing, and keeping the ice before it was delivered. (Margo Thornley, *Iceman of the Post Road*, 1983.)

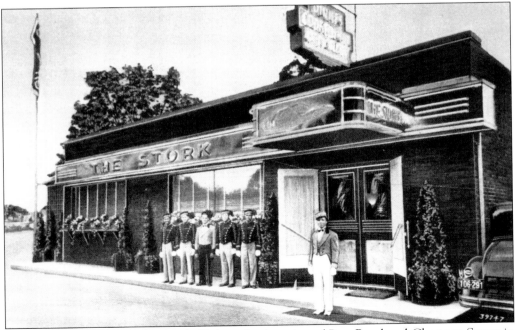

A Night on the Town. The Stork Club at the junction of Post Road and Chestnut Street in Norwood was one of Warwick's most popular nightclubs. During the period following World War II, Warwick was the place to go for a "night out." (Henry A.L. Brown Collection.)

The Cycle Club. Cycling in Warwick was a very popular sport in the nineteenth century. H.C. Babcock and E. Clarke of Warwick are included in this 1876 tintype of the Elmwood Cycle Club. (Henry A.L. Brown Collection.)

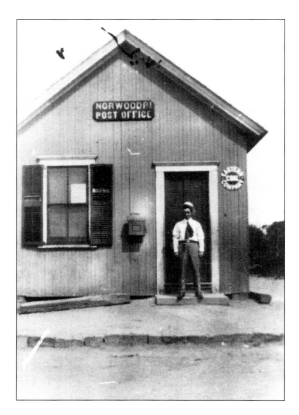

The Norwood Post Office in 1899. Postmaster Carlton Budlong is in the doorway. (Thomas E. Greene Collection.)

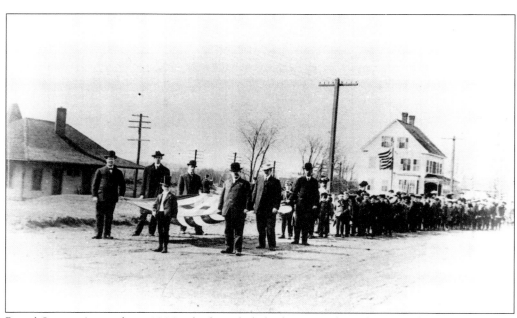

Broad Street. A parade in 1906, which included a large number of Norwood School students, pauses in front of the railroad station. (Edward Keene Collection.)

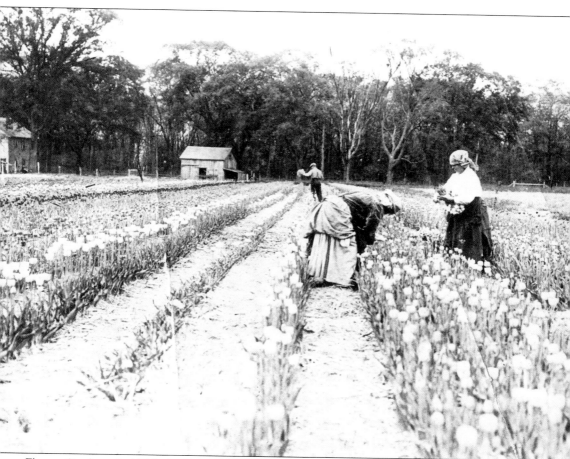

Flower Gardens. In 1915, the Hoxsie flower gardens were magnificent. They were located across from the present-day Gateway Plaza on Warwick Avenue. "Big Rosie" and "Little Old Maria," two Italian immigrants, came from Olneyville by trolley to work as flower pickers. Flowers from Hoxsie were shipped to other sections of New England. Hoxsie was also a leading area for growing fruits and vegetables. (J. Bourgaize Collection.)

John Olney Nelson Hoxsie House in 1890. John Hoxsie was one of Warwick's best-known agriculturists. At one time he had over 275 acres under cultivation and was the largest market gardener in Warwick. This beautiful home was on the westerly side of Warwick Avenue where the Gateway Shopping Plaza is now located. (Hazel Crandall Collection.)

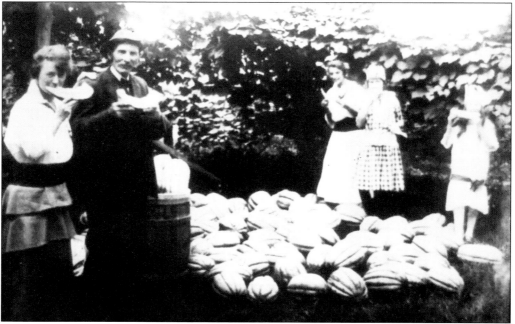

Prize Fruit. Grown in Hoxsie by Postmaster Benjamin Franklin Moore, these melons drew crowds during the harvest season. (Henry A.L. Brown Collection.)

Three
SHORE ATTRACTIONS

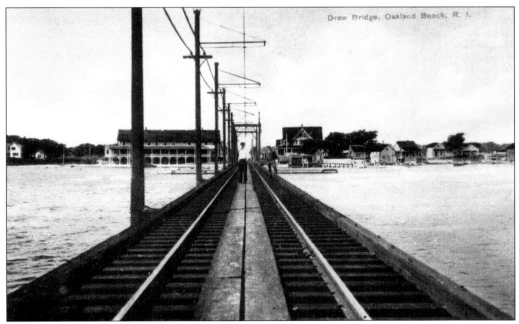

Oakland Beach. This area became an important summer resort when the Warwick Railroad ran its first passenger train from Providence to the beach on July 4, 1874. In 1881, the Warwick line was taken over by the New York, Providence, and Boston Railroad and the tracks were extended across Oakland Beach to Buttonwoods. This drawbridge went across Warwick Cove and brought passengers to the beach near the Pleasant View Hotel (later the Bayview restaurant). (Henry A.L. Brown Collection.)

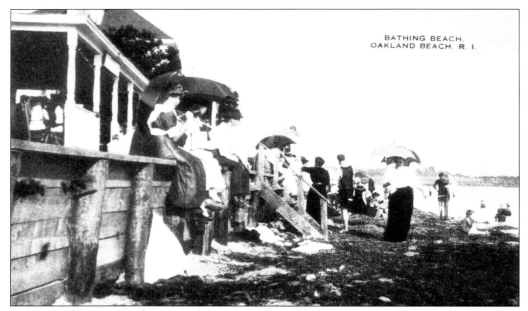

A Day in the Sun. By the turn of the century, Oakland Beach became the favorite summer playground for the mill workers of Providence, who found transportation to the park inexpensive and easy because of the trolley. (Henry A.L. Brown Collection.)

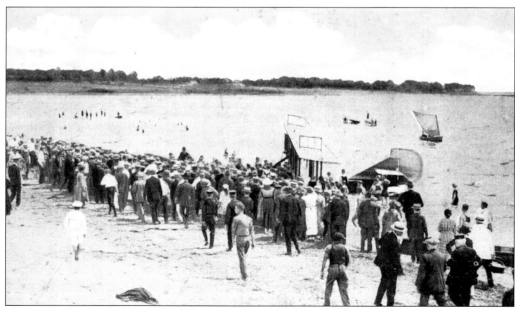

Showtime. Everyone was thrilled by the antics of Jack McGee and his amphibious plane as he performed for this Oakland Beach crowd, c. 1916. McGee met a tragic death a few years later while testing planes for the Gallaudet Company. (Dorothy Mayor Collection.)

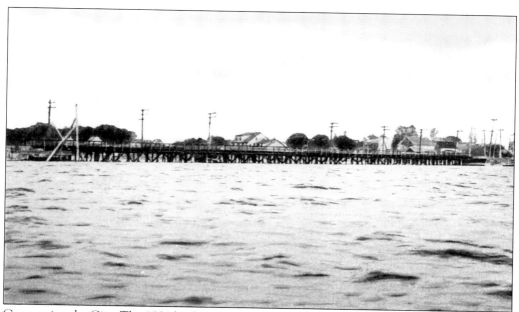

Connecting the City. The 1881 bridge across the mouth of Brushneck Cove connected Oakland Beach and Buttonwoods. Trolley cars could then go through Apponaug and on to Westcott and Riverpoint. In 1916, Frank Stender rebuilt the structure with a raised span to allow boat passage. (Dorothy Mayor Collection.)

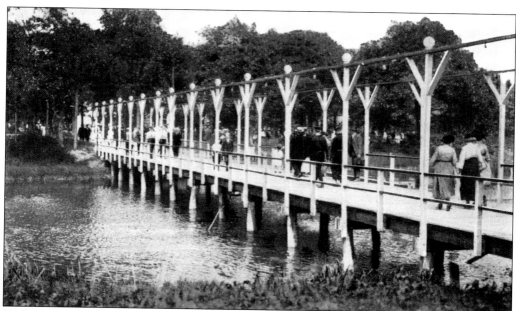

Bridge at Oakland Beach. Young couples favored this handsome bridge which led from the amusement center to the picnic grounds at Oakland Beach. (Dorothy Mayor Collection.)

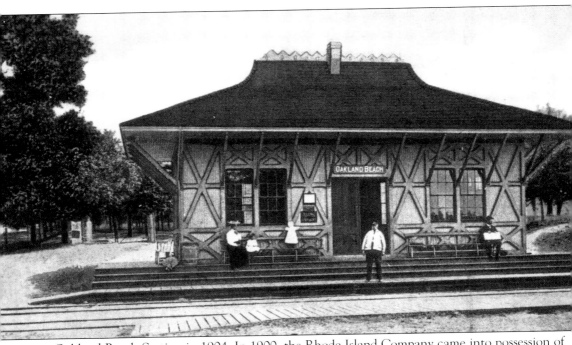

Oakland Beach Station in 1904. In 1900, the Rhode Island Company came into possession of the railroad and replaced the steam power with electricity. With inexpensive and relatively fast transportation, workers from the mill towns, no longer confined to the limits of the village, could travel to the beach on "bloomers," or open cars. During this summer the station at the midway saw huge crowds coming and going throughout the day. (Henry A.L. Brown Collection.)

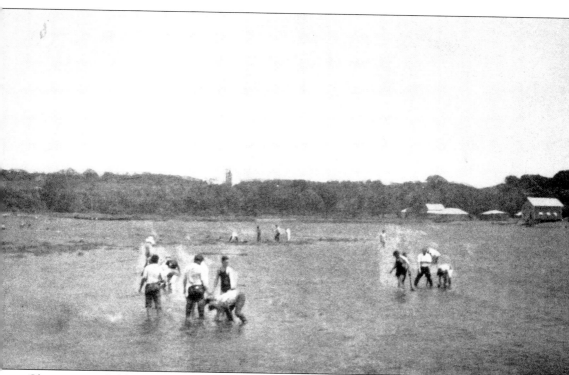

Clamming at Oakland Beach. While D. Russell Brown, a wealthy Providence businessman and former governor of Rhode Island (1892–95), was struck by the natural beauty of the peninsula and sought to develop it as a fashionable resort, others were attracted to the area because of the abundance of shellfish. As Oakland Beach was ideally situated in the cove, clamming at low tide was a regular summer event for many. (Henry A.L. Brown Collection.)

Happy 100th Birthday! In 1919, Joseph Carrolo recognized the potential of Oakland Beach as an amusement center as he watched the huge crowds coming by trolley. He was instrumental in making the beach one of the most attractive amusement centers in Rhode Island. He celebrated his 100th birthday with the help of his daughter, Mrs. Alice Rounds, and his friend, Joseph Muratore. (Marie Izzi Collection.)

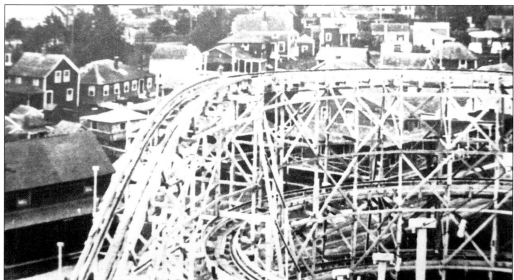

The Roller Coaster. Always a major attraction, this midway fixture was destroyed by the Hurricane of 1938, which heralded the end of the once popular summer playground. (Warwick Historical Society Collection.)

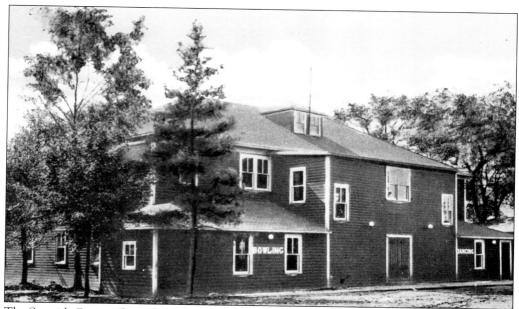

The Spanish Casino. One of the major gathering places for young people well into the twentieth century, this structure later served as Oakland Beach's bowling alley and roller-skating rink. After a devastating fire, it was torn down in 1963. (Dorothy Mayor Collection.)

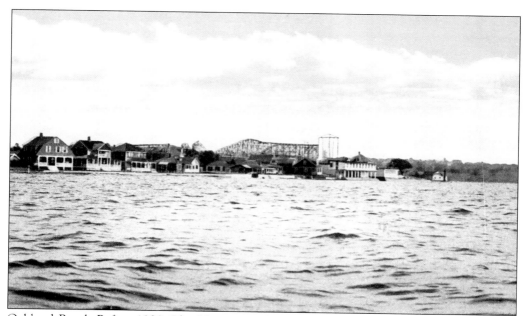

Oakland Beach Before 1938. The Hurricane of September 21, 1938, smashed into Warwick with a fury seldom seen in the northeast. It left 262 persons dead and caused an estimated damage of $100 million. One of the areas most heavily damaged was Oakland Beach; a tidal wave destroyed nearly all the buildings seen in this picture. (Dorothy Mayor Collection.)

Saint Rita's Catholic Church. Built in 1911 as a chapel mission, Saint Rita's served many Irish immigrants at Oakland Beach and Buttonwoods who previously had to take the trolley to attend Saint Catherine's in Apponaug. The church was named after Saint Rita, the Saint of the Impossible. In 1935, Saint Rita's Parish was established. (Dorothy Mayor Collection.)

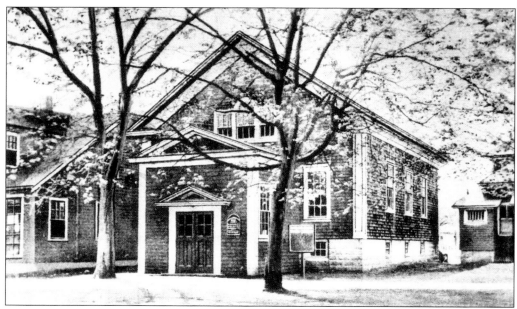

The Oakland Beach Union Church. Completed in 1914 to meet the needs of the ever-increasing number of summer residents, the church became affiliated with the Congregational Christian Conference in 1952. It then became the first Congregational church in the city of Warwick. (Henry A.L. Brown Collection.)

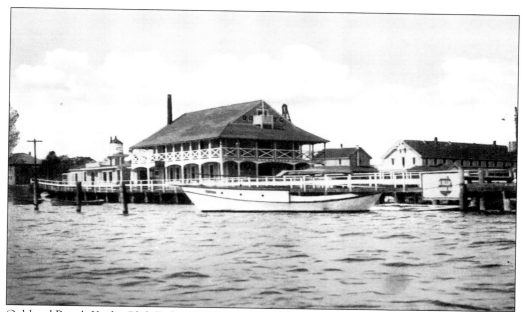

Oakland Beach Yacht Club Before 1938. Frank Stender brought the yacht club from Providence to Oakland Beach by barge in 1917. It was destroyed by the 1938 Hurricane. To the right of the yacht club is the former Pleasant View Hotel, now the Bayview restaurant. (Dorothy Mayor Collection.)

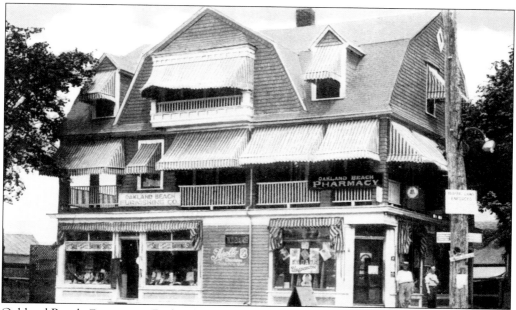

Oakland Beach Commerce. Richard's Pharmacy and Salk's store occupied the lower level while the Oakland Beach Hotel occupied the upper level of this building, located on the corner of Oakland Beach Avenue and Suburban Parkway. (Dorothy Mayor Collection.)

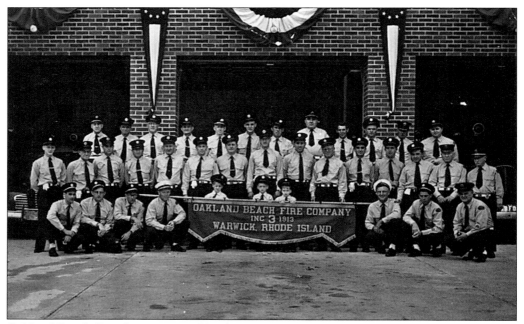

Oakland Beach Fire Station in 1955. The company's last volunteers are pictured in front of the newly-built station. Kneeling fourth from the left is Deputy Chief Thomas Bonn, and third from the right is Chief Jim Bonn. The mascots are, from left to right: George Bonn, Donald Lannon Jr., and Thomas Bonn Jr. (Oakland Beach Firemen's Club Collection.)

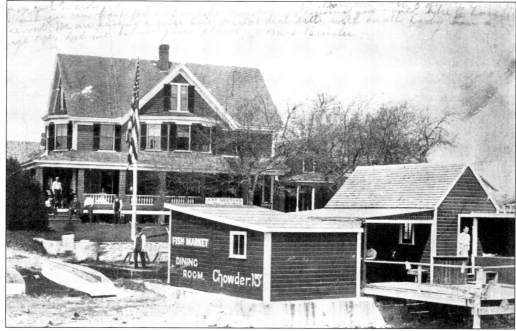

Harry Stearn's Residence and Fish Market, c. 1920. Stearn's small store featured everything from light groceries to fresh fish. It was located at the end of Delaware Avenue (Suburban Parkway). (Henry A.L. Brown Collection.)

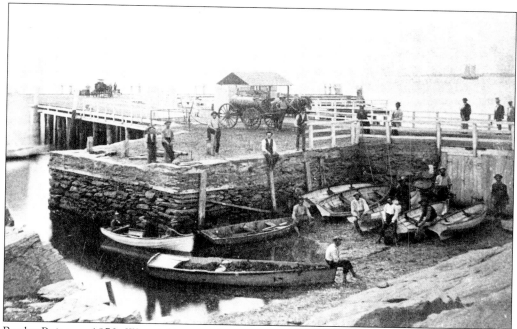

Rocky Point, c. 1870. Warwick's most famous amusement park, founded by Captain William Winslow nearly one hundred and fifty years ago, is now about to close its doors. It is with sadness and a sense of great loss that we accept the news. Fortunately, many fond memories live on. (Henry A.L. Brown Collection.)

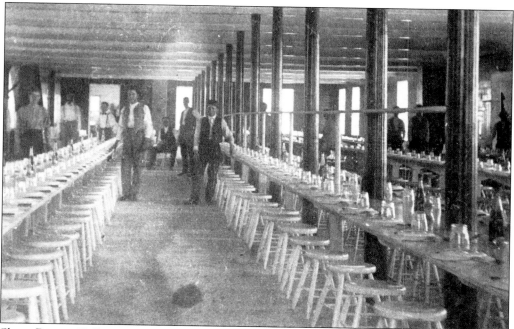

Shore Dinner Hall in 1876. Thousands came from all over New England to feast on clams and lobsters at Rocky Point. Workers at the hall made sure everything was prepared for the crowds that were sure to come. (Henry A.L. Brown Collection.)

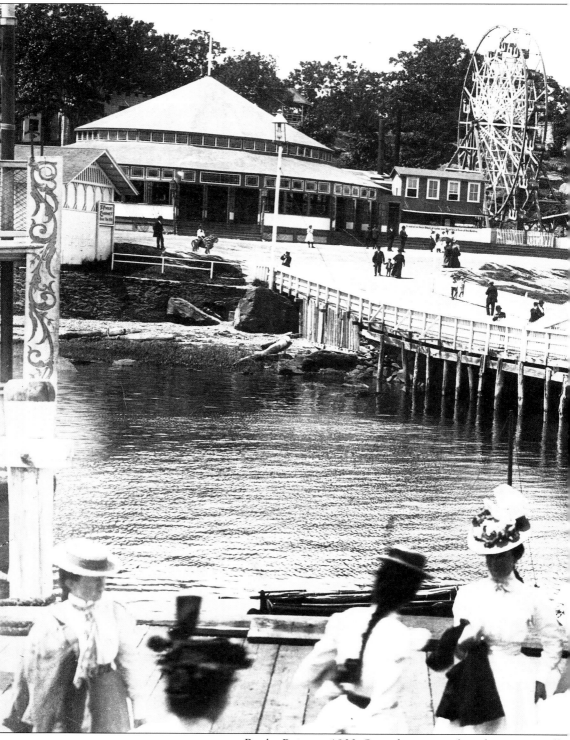

Rocky Point, c. 1900. Steamboats were kept busy, especially

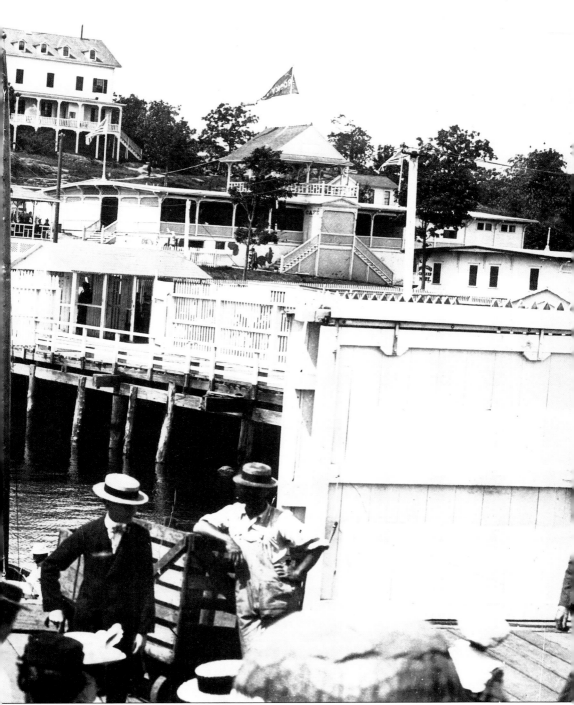

on Sundays, taking merrymakers to Rocky Point

The Rock Cafe at Rocky Point. Since the mid-nineteenth century, Rocky Point has meant many things to many people. It has met the needs of those on a Sunday school picnic or those seeking more formal dining at the Rock Cafe. (Henry A.L. Brown Collection.)

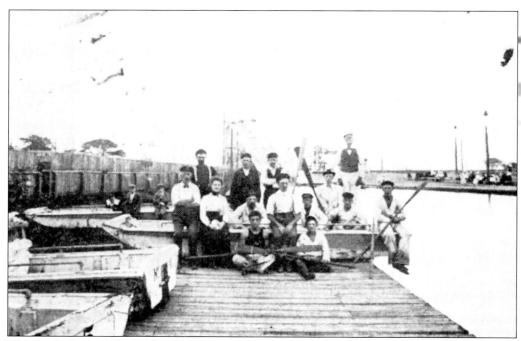

The Rocky Point Chutes. Rocky Point was known for its new and exciting rides. One of the most popular amusements in the early twentieth century was the Rocky Point Chutes. (Henry A.L. Brown Collection.)

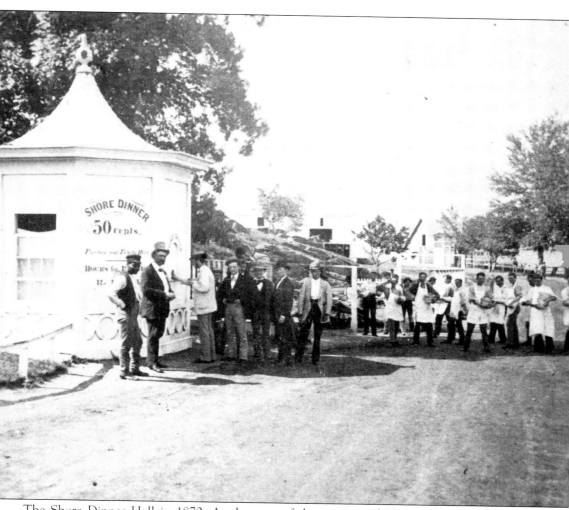

The Shore Dinner Hall in 1870. At the start of the summer of 1870, Louis H. Humphrey, the gentleman with the high hat, called out his workers for this photograph. Because of the volume of business done during the summer months, it was necessary to have a large staff, and Rocky Point prided itself in its ability to serve large numbers with great efficiency. Humphrey successfully managed the park for the American Steamboat Company. Note the price of a shore dinner. (Henry A.L. Brown Collection.)

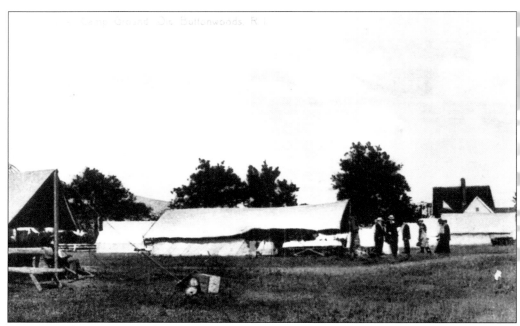

Buttonwoods Campground in 1909. The Buttonwoods Beach Association established a fine resort area with strict rules for building and membership. Philanthropist Henry Warner Budlong believed there should also be such an area for working-class city residents. As a result, a portion of his property along the Greenwich Bay shore was used to establish the Buttonwoods Campground. (Henry A.L. Brown Collection.)

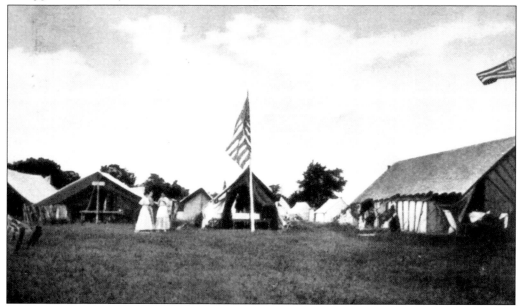

The Campground in 1911. During the early twentieth century, families moved into tents for a pleasant summer at Buttonwoods. Here a few women enjoy the cool breezes of the Warwick shore. City residents, hoping to beat the heat of the summer, often came by trolley to the campground for even a brief retreat. (Henry A.L. Brown Collection.)

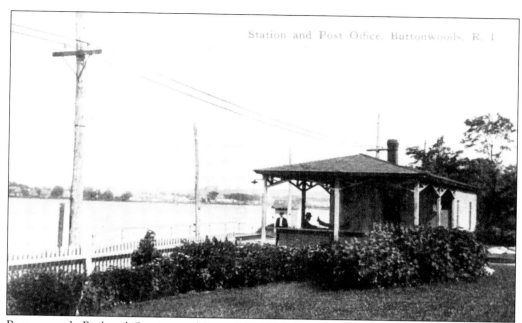

Buttonwoods Railroad Station and Post Office, c. 1900. When the New York, Providence, and Boston Railroad built a bridge across Brushneck Cove to Buttonwoods in 1881, the area was more easily accessible. The coming of the trolley in 1900 brought many to enjoy the cool breezes by the shore at the campground. (Henry A.L. Brown Collection.)

Buttonwoods Beach. This section of Buttonwoods, established by the Cranston Street Baptist Church to meet the needs of area Protestant families, was not far from the campground in geographical distance, but was very distant in terms of the lifestyles it maintained. The Buttonwoods Beach Association, led by the Reverend Moses Bixby, modeled the resort after Oak Bluffs on Martha's Vineyard. (Henry A.L. Brown Collection.)

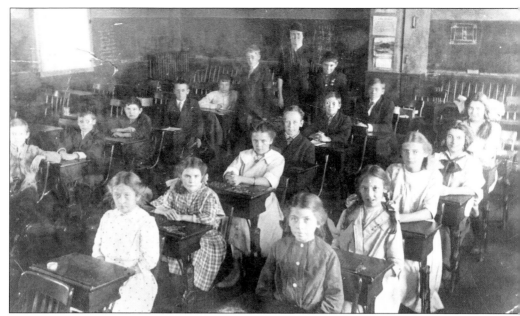

The Buttonwoods School in 1910. Photographing students in the classroom was a difficult task in 1910 because of the hazards of flash photography. Fortunately, this photographer was successful. The school population reflects the growth of Buttonwoods from a summer resort to a year-round community. (Dave Matteson Collection.)

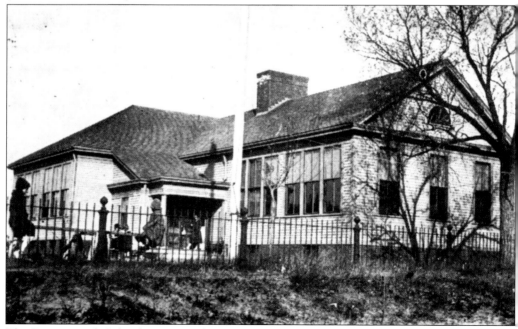

The Buttonwoods School in 1916. This structure, located on West Shore Road at Buttonwoods Avenue, was built in 1916. After its use for public education, the building was used for a variety of purposes. Greatly changed and renovated, it provides the nucleus for the Buttonwoods Senior Center, which was completed in 1991.

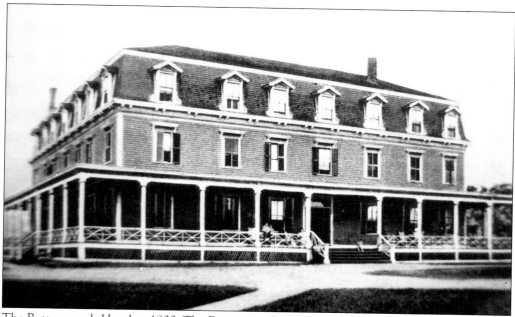

The Buttonwoods Hotel, c. 1900. The Buttonwoods Beach Association built this hotel in 1872. It was eventually closed and demolished in 1909–10. At about this time, the association hired Providence engineer Niles B. Schubarth to create a picturesque suburban area. (Henry A.L. Brown Collection.)

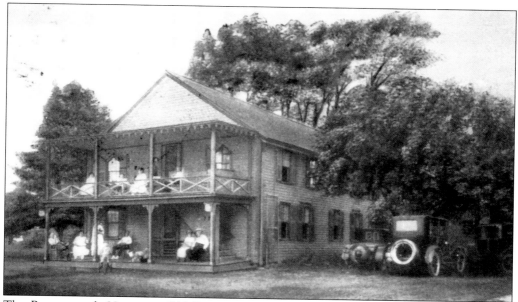

The Buttonwoods House, or Old Buttonwoods. This house on the corner of Hemlock and Promenade Avenues was the site of the Kinnecom family clambakes. One of the most famous was given for William Henry Harrison during the presidential campaign of 1840. The house later became a nursing home and was demolished a few years ago. (Henry A.L. Brown Collection.)

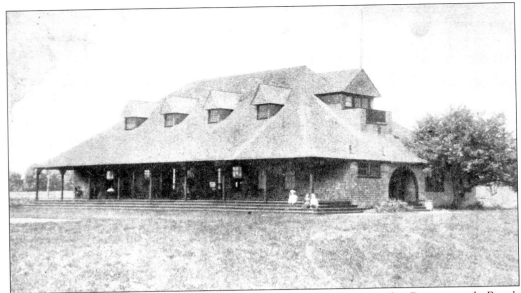

Buttonwoods Casino. Spurred by the growth of the beach colony, the Buttonwoods Beach Association built a casino in 1896 on the corner of Janice Road and Cooper Avenue. The growth of the area came as a result of visitors brought in the 1870s via a horsecar line from Apponaug and later by the Warwick Railroad. (Henry A.L. Brown Collection.)

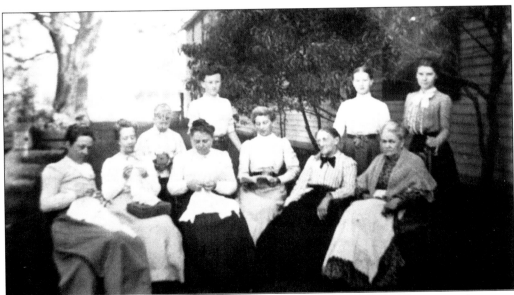

A Respectable Environment. The concept behind the development of Buttonwoods was to provide a summer colony where people could combine recreational and religious activities in a "wholesome, respectable environment." The ladies in this sewing circle seem to have been imbued with that spirit. (Warwick Historical Society Collection.)

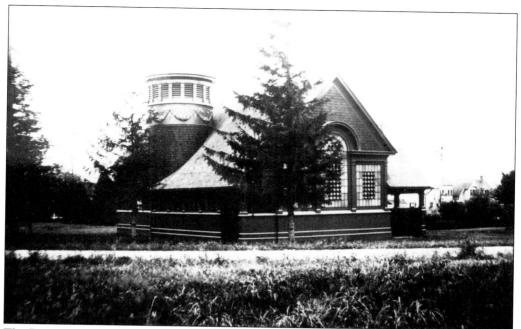

The Buttonwoods Chapel in 1901. The Union Chapel, located at 1003 Buttonwoods Avenue, was designed by Howard Hoppin and was built in 1884–85. It features a large stained-glass Palladian window in the front and a handsome cylindrical tower on the side. (Warwick Historical Society Collection.)

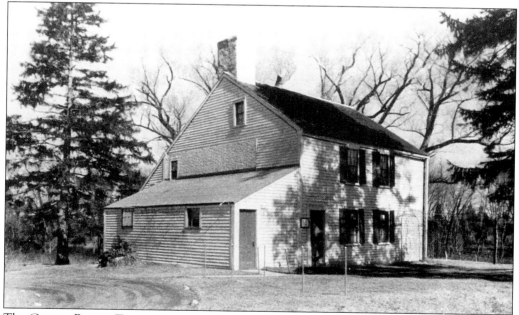

The Greene-Bowen-Tyson House at 100 Mill Wheel Road. Built by James Greene or his son, Fones Greene, between 1687 and 1715, the house remains as one of Warwick's oldest. In 1982, it was acquired by Steve and Jean Tyson, who have restored this historic home, which was once in danger of being demolished. (Henry A.L. Brown Collection.)

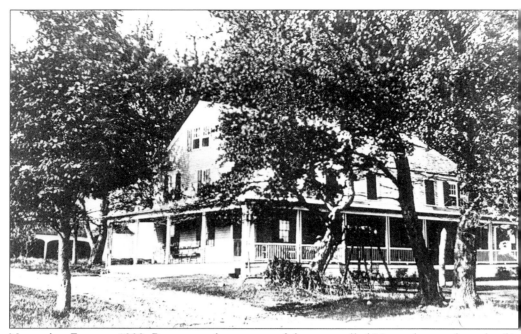

Nausauket Farm, *c.* 1900. Buttonwoods was part of the area called Nausauket, and much of it remained farmland well into the twentieth century. Like many other Warwick communities, Nausauket became a popular summer playground when the trolley lines were extended. (Donald Skuce Collection.)

Nausauket Beach, *c.* 1910. Early in the twentieth century summer cottages began to appear in Nausauket. The beach remained a pleasant summer retreat, away from the boisterous crowds that flocked to the amusements of Rocky Point and Oakland Beach. (Donald Skuce Collection.)

Baynes Beach, Longmeadow, in 1908. Thanks to the trolley and then the automobile, the waterfront at Longmeadow became a fashionable place in which to summer. In time, substantial Victorian homes graced the area. The Hurricanes of 1938 and 1954 destroyed much of the property along the beach. (Henry A.L. Brown Collection.)

Riverview Park in 1908. Before the Hurricane of 1938, the Riverview section of Warwick, near Mill Pond Cove, had developed into a lovely suburban community with many fine homes. Like Longmeadow a little to the south, Riverview began as a summer colony. (Henry A.L. Brown Collection)

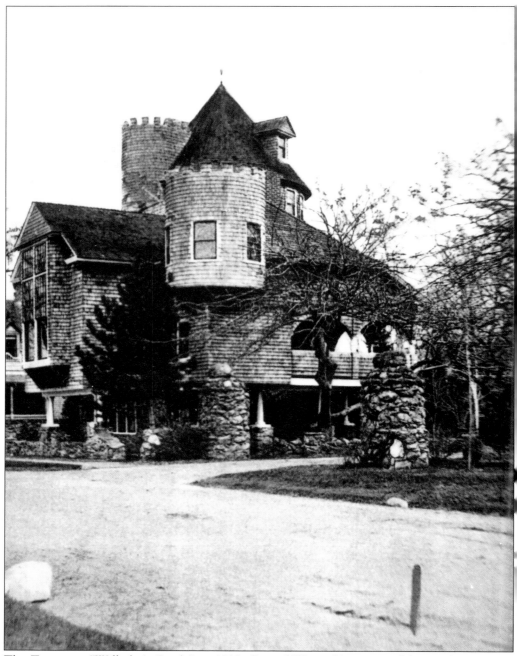

The Towers or "Wilhelm's Castle" in 1908. One of Warwick's most well-known homes, this large and unique house at 200 Longmeadow Avenue was built by Elijah Baxter in 1892. The famous artist, one of the founders of the Rhode Island School of Design, envisioned this as the gatehouse of a mansion that would rival those of Newport. Unfortunately, Baxter's fortune ebbed and his dream was never realized. Later, George Wilhelm, the well-known brewmaster of the Narragansett Brewery, acquired the house (hence its name). (Henry A.L. Brown Collection.)

Four

MILL VILLAGES

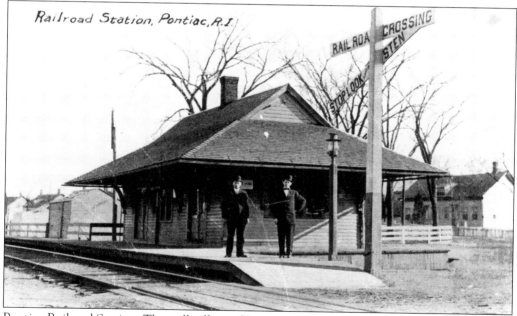

Pontiac Railroad Station. The mill village of Pontiac, formerly Clarkesville, became significant when Robert Knight and his brother Benjamin purchased the mill in 1850 for $40,000. Under the B. B. & R. Knight Company, the Pontiac Mill became a leader in the textile industry and one of the important stops on the railroad. The old station is now part of the Great House Restaurant on Post Road. (Bob Byrnes Collection.)

The Pontiac Bridge in 1924. By the mid-1920s the state began to make a number of changes in roads in Warwick to accommodate the increasing number of motor vehicles. The old bridge became part of the state road now known as Greenwich Avenue. (Henry A.L. Brown Collection.)

The First Pontiac School in 1850. The B. B. & R. Knight Company, in the tradition of paternalism which was prevalent throughout the nineteenth century, did a great deal to help support the school and library in its area. (Thomas E. Greene Collection.)

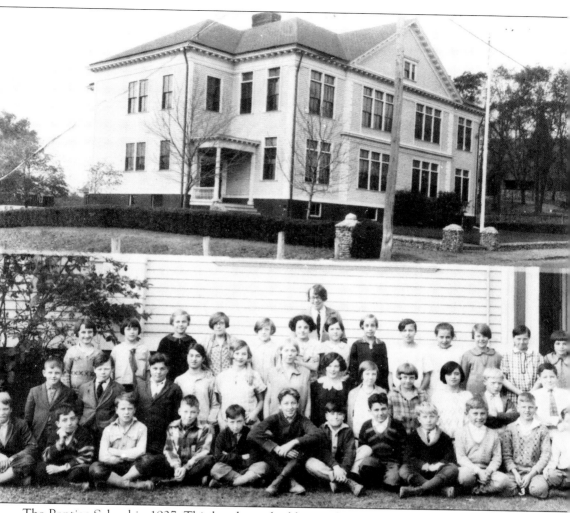

The Pontiac School in 1927. This handsome building replaced the old one-room schoolhouse of the mid-nineteenth century. For years it was an easily-recognized landmark in Pontiac. The teacher shown here is Marianna Willard, who for over fifty years taught everything from math to music in the Warwick schools. If you went to Warwick schools, chances are you met Miss Willard. The school has been demolished and a small park now graces the area near West Natick Road and Greenwich Avenue. (Mildred Longo Collection.)

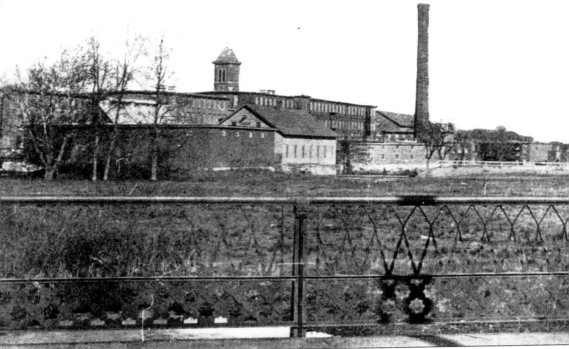

ntiac Mill & Bleachery, Pontiac, R.I.

The Pontiac Mill and Bleachery. These institutions dominated the village in every aspect. The B. B. & R. Knight Company, whose "Fruit of the Loom" trademark is recognized worldwide, owned the mill originally, but sold their interests (including their name and trademark) to the Consolidated Textile Corporation following World War I. During the 1930s, the mill attempted to cut costs by increasing production and cutting wages. These measures failed, leading to a strike and the eventual demise of the textile industry in the village. (Bob Byrnes Collection.)

Grandquist House in 1940. In the period preceding World War II, horse-drawn sleighs could still be seen in Pontiac. These neighbors gathered in front of the Grandquist house in the winter of 1940. Frank Jefferson was the driver and Earl and Lloyd Fish are in the picture. (Lloyd Fish Collection.)

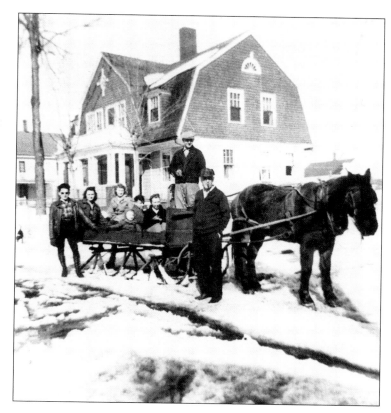

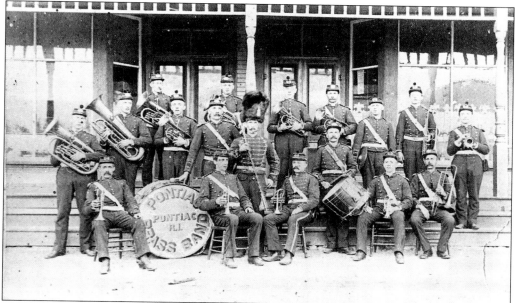

Pontiac Brass Band in 1890. The band is shown here in front of Johnson's store. Every Friday night during the summer months, they entertained the village and also played special programs at the school and library. (Mildred Longo Collection.)

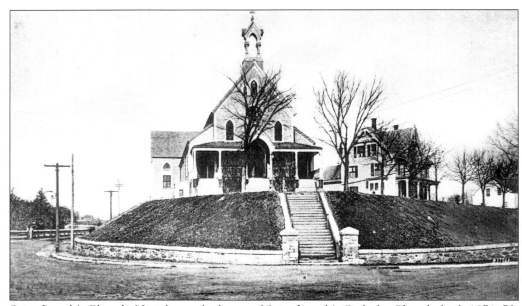

Saint Joseph's Church. Natick was the home of Saint Joseph's Catholic Church, built 1871–72, and many Catholics from nearby Pontiac joined fellow worshippers here every Sunday. For a period of time in the nineteenth century, the church served two separate and distinct congregations: one spoke English, while the other spoke French. (Henry A.L. Brown Collection.)

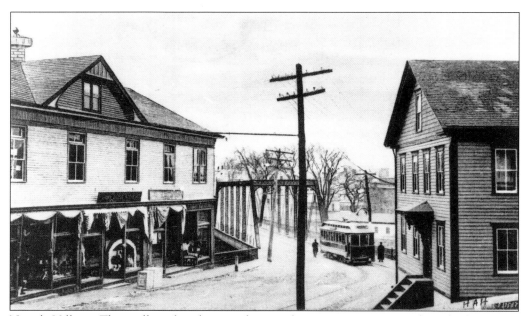

Natick Village. The trolley played a significant role in connecting Natick with the rest of Warwick, as can be seen here in 1907, when the village was thriving and still a part of Warwick. (Richard Seimbab Collection.)

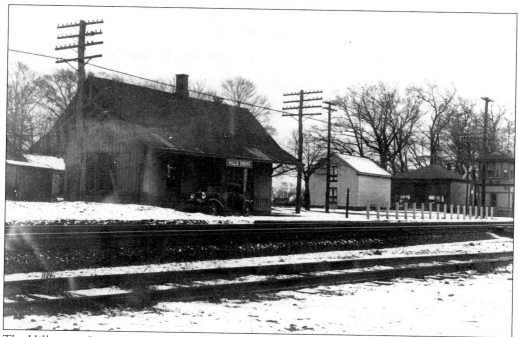

The Hillsgrove Station. Hillsgrove, named for its founder, Thomas J. Hill, depended a great deal upon the railroad for receiving and shipping goods. The old railroad depot was an integral part of village life. The building at the right of the station, once a post office, is now the Sandwich Junction restaurant. (Hillsgrove United Methodist Church Collection.)

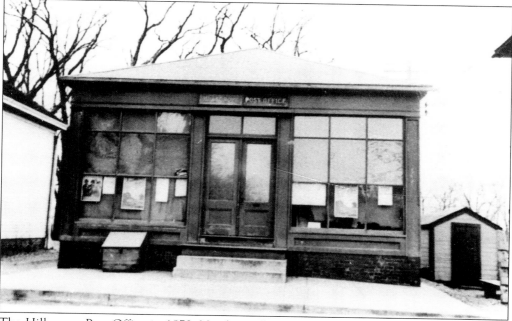

The Hillsgrove Post Office in 1872. Not long after 1867, when Thomas J. Hill built the R.I. Malleable Iron Works that started the village, this building served as a store and post office. (Thomas E. Greene Collection.)

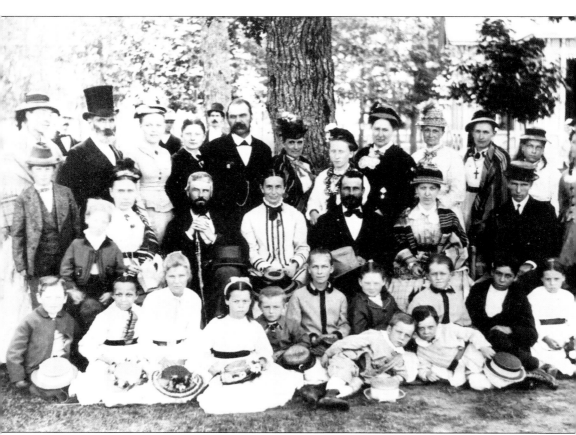

Sunday School at Hillsgrove in 1876. Thomas Jefferson Hill, like other mill owners of the nineteenth century, exerted his influence in nearly all aspects of village life. Shortly after he opened his iron works and mill in 1875, the village grew to forty-nine inhabitants. Hill used his influence and generosity to help establish the Hillsgrove United Methodist Church. This is the first Sunday school group at the church, *c.* 1876. (Hillsgrove United Methodist Church Collection.)

Kilvert Street. Kilvert Street was still a dirt road in the nineteenth century. This view is from the railroad track looking toward present-day Post Road. The Hillsgrove Methodist Church is on the left. (Hillsgrove United Methodist Church Collection.)

Wedding Party. Kids really used their imaginations and made their own fun at this "Tom Thumb Wedding" in 1911. Included in the wedding party were Mildred Bassett, Kathleen Carter, Ursula (Maine) Ross, and Elwood Carter. (Hillsgrove United Methodist Church Collection.)

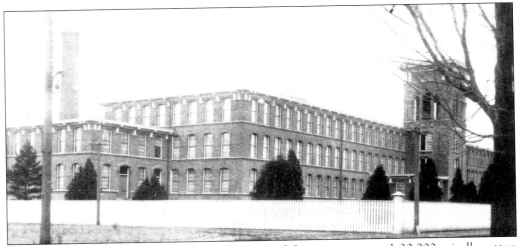

Elizabeth Mill in 1875. Thomas Jefferson Hill named this steam-powered, 20,000-spindle cotton mill in honor of his wife, Elizabeth Kenyon Hill. He planted a line of trees along Kilvert Street and Jefferson Avenue (now Jefferson Boulevard), and prompted the village to be named "Hill's Grove." (Thomas E. Greene Collection.)

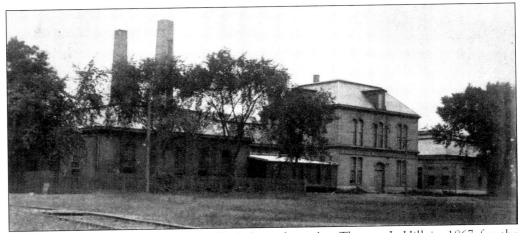

R.I. Malleable Iron Works in 1904. Built by industrialist Thomas J. Hill in 1867 for the manufacture of malleable iron castings, the factory provided the nucleus for the village that was to grow around it. This building burned in 1918 and was replaced by the present structure at Jefferson Boulevard and Kilvert Street. (Henry A.L. Brown Collection.)

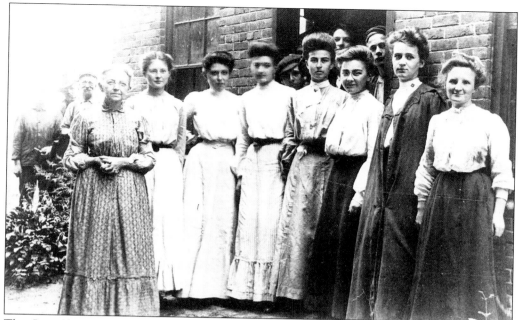

The Care Shop. The establishment of Thomas Hill's foundry, the R.I. Malleable Iron Works, marked the beginning of the growth of the area once called "the plains." The foundry attracted a number of skilled workers, such as the ladies in this Care Shop group of 1917. (Thomas E. Greene Collection.)

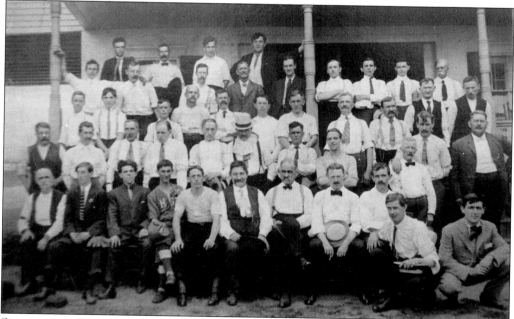

Summertime Outing. In 1911, foundry work was very difficult and often dangerous. The pay was low and the hours long. One of the nicest aspects of life in Hillsgrove then was the annual summer outing, when workers were taken to the shore for the day. (Warwick Historical Society Collection.)

Hauling for the Mills. Marzy Lincoln of Greenwood, a Civil War veteran, was a driver for Hill's Grove Mills. His daughter, Vera Harris Lincoln, relates that Marzy, too young to join the army, used a pseudonym in order to qualify. Marzy and his wife Elizabeth took care of the Buttonwoods Hotel and were very active in the First Free Will Baptist Church in Greenwood. (Ralph Cook Collection.)

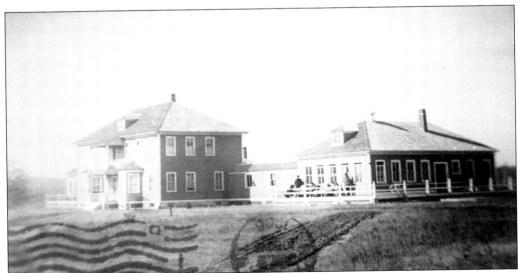

The Sanatorium. Believing that the country air of Warwick was preferable to that of Providence, the state established a sanatorium, or TB hospital, at Hillsgrove. In 1906, the hospital was moved to Wallum Lake in Burrillville. (Henry A.L. Brown Collection.)

The Firemen's Ball. Mayor and Mrs. Joseph Mills attended the Firemen's Ball in 1952, at Sholes Roller Skating Rink in Hillsgrove. Second from the left is Lambert Lind. Next to him are Mrs. Joseph McKeever, Mr. Joseph McKeever, Mayor Mills, and Mrs. Mills. (Greenwood Volunteer Fire Company #1 Museum Collection.)

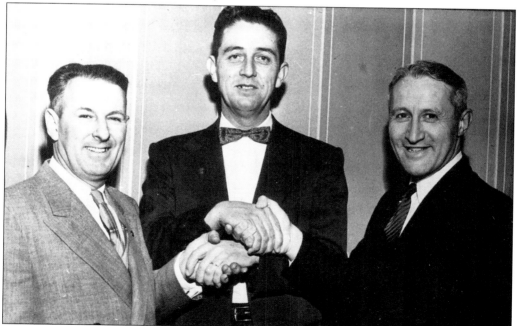

In Charge. When Warwick inaugurated its first permanent fire department, the three men selected to lead it were Chief Thomas Duckworth (center), Deputy Chief Harold Smith (to the right of Chief Duckworth), and Deputy Chief Frank White (to the left of Chief Duckworth). (Greenwood Volunteer Fire Company #1 Museum Collection.)

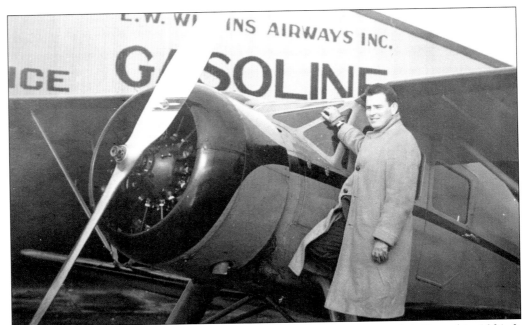

The Airport. Hillsgrove was selected as the site for the state airport and dedicated in 1931. It was the first state-owned airport in the United States. At that time, flying had not yet become sophisticated and pilots were real daredevils. Here Kirby Fritz is shown before the E.W. Wiggins hanger, c. 1935. (Kirby Fritz Collection.)

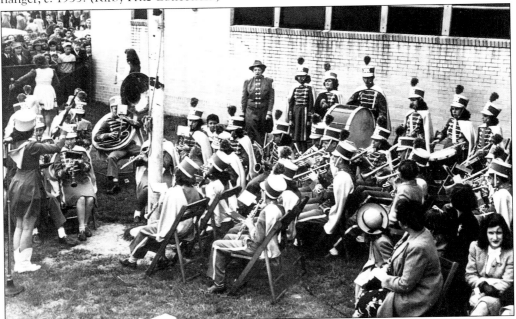

Wartime Rallies. During World War II the airport was taken over by the federal government for the duration of the war. The Warwick High School band, shown here at Hillsgrove, did its part for the war effort by playing at bond rallies and participating in parades to bolster morale. (Albert Ruerat Collection.)

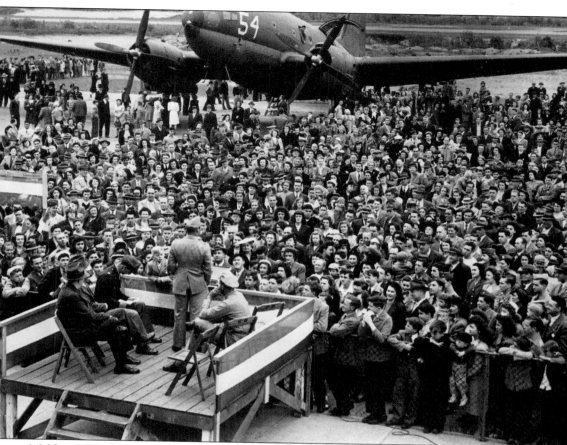

A Military Display. In June 1945, large patriotic crowds gathered at the T.F. Greene Airport at Hillsgrove to see the latest bombers and participate in patriotic displays. The U.S. Army used the Hillsgrove facility for training fighter pilots. One of the units trained at Hillsgrove was called the "Checkertail Clan" and holds the distinction of being the first group in the U.S. Army Air Force to fight as a unit with an identifying logo. The airmen in this group, along with many others who spent time at the air facility, went on to serve with great distinction during the war. After the war, the Hillsgrove Airport was returned to the state. (Albert Ruerat Collection.)

Saint Mary's in Crompton, c. 1884. Built at a time of anti-Catholic prejudice, this was the first Catholic Church in the Pawtuxet Valley. For a time, it was serviced by priests who traveled on horseback from village to village. At that time, Crompton was part of Warwick. (Saint Mary's Church Collection.)

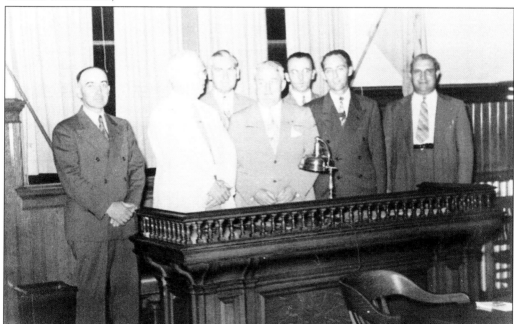

Burning the Bonds in 1944. Warwick and West Warwick separated in 1913 and each assumed a share of the common debt. In 1944, Colonel Patrick H. Quinn, "Mr. West Warwick" (shown here second from left), presided over the ceremonial "burning of the bonds." (Albert Ruerat Collection.)

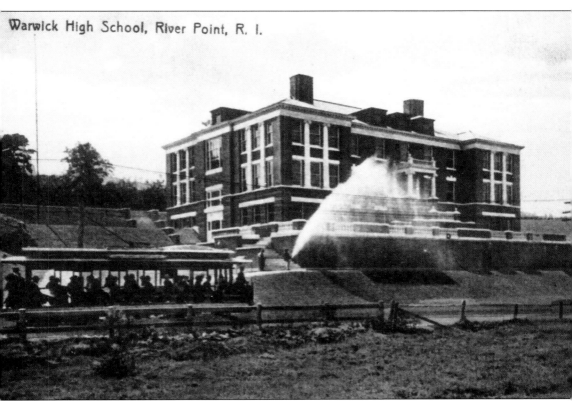

Warwick High School, River Point, R. I.

Warwick High School in 1909. By the turn of the century, there was a demand for high school education. In 1904–05, to serve the needs of Warwick and much of Kent County, a two-story, red brick school building was built between Providence Street and New London Avenue in the village of Westcott. Trains and trolleys brought students from as far away as Pawtuxet in Warwick and Greene in Coventry to the handsome school building. When the town was divided in 1913, West Warwick received the high school while Warwick kept the town hall. The facade was altered in 1983 and a large addition was made to the original building. Today the structure, known as Wescott Terrace, provides housing for the elderly. (Henry A.L. Brown Collection.)

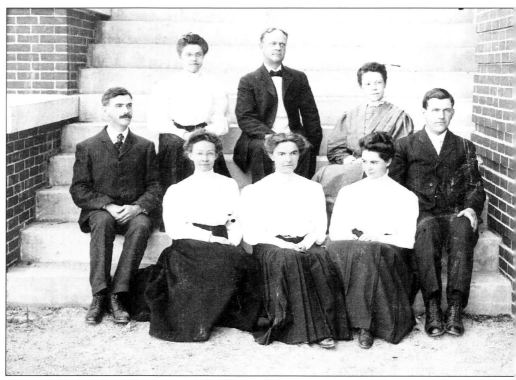

Warwick High School Faculty in 1909. The small faculty of the old Warwick High School had to make a tough choice in 1913. Some elected to stay in Westcott when the facility became the West Warwick High School. (Thomas E. Greene Collection.)

Apponaug Grammar/High School, c. 1905. As a result of the division of Warwick in 1913, the Apponaug Grammar School on Post Road became the town's high school. This building was destroyed by fire in 1923. Today, the Trudeau Center stands on the site. (Thomas E. Greene Collection.)

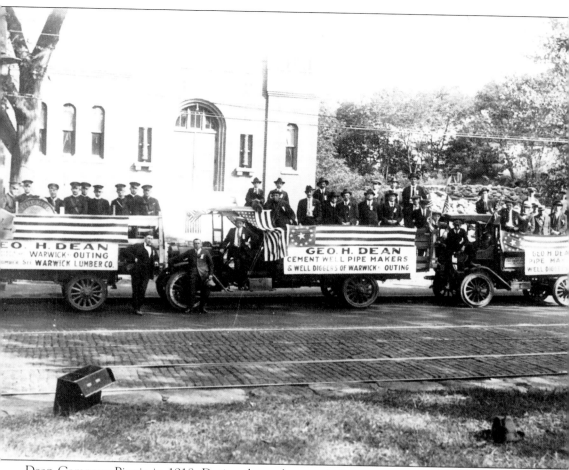

Dean Company Picnic in 1918. During the early twentieth century, outings and picnics were common, especially around the Fourth of July. Employees of the George H. Dean Company gathered in front of the armory at 3259 Post Road on the way to an outing along the shore. On the facade of the building are the words "Kentish Artillery," with the dates 1797 and 1912. The first date indicates the founding of the Kentish Artillery and the date of the building of the wooden armory. This burned in the fire of 1911 and the brick structure, now the Warwick Museum, replaced it in 1912. Note the cobblestones, the streetcar tracks, and the absence of Saint Barnabas's Church, which also burned in 1911. (Phyllis Dean Collection.)

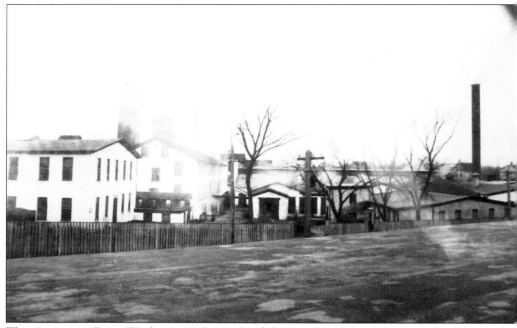

The Apponaug Print Works in 1917. Much of the success of the Apponaug Company came as a result of the business acumen of J.P. Farnum and the talents and skills of Alfred J. Lustig, a master chemist. Lustig, who became president of the company in 1917, brought the mill to national importance. (Warwick Historical Society Collection.)

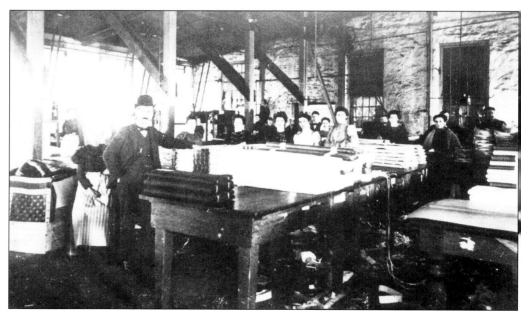

The Apponaug Finishing Room in 1900. Young women were often thought to be the best workers in the finishing rooms of textile mills. The Apponaug Bleaching, Dyeing, and Print Works Company (later the Apponaug Company) concentrated on the printing of staple cotton fabrics. (Dorothy Mayor Collection.)

Five

OLD WARWICK VICINITY

John R. Waterman House, c. 1890. This handsome house was built by John R. Waterman in 1800 on land of his ancestor, Richard Waterman, one of the original purchasers of Warwick. The two workers with the Belgian horses were descendants of slaves who once lived on the property. Dr. William and Eileen Naughton have restored the beautiful old homestead in recent years. (Warwick Historical Society Collection.)

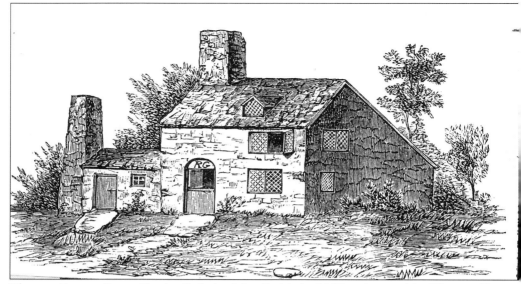

Thomas Greene Stone Castle. Built by John Smith in 1649 and owned by Thomas Greene during the Indian war, this was reported to be the only building in Warwick not burned to the ground in King Philip's War (1675–76). The site is now the parking lot for the Elks Lodge #2196, on 1915 West Shore Road. (Sketch by Mrs. John Wickes Greene, 1875.)

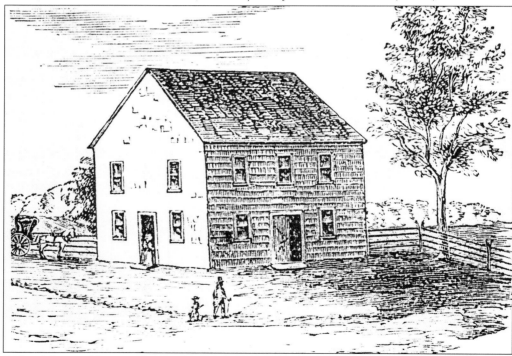

Oldest Meeting House in Warwick, c. 1700. This Six-Principle Baptist Church was taken down in 1830, in a "very decayed condition." According to O.P. Fuller's *History of Warwick* (1875), it was 40 feet square, and had two doors, "one on the side facing the Conimicut road...and one fronting Meeting-House Road." (Sketch by Mrs. C.W. Colgrove, 1875.)

Old Warwick League Library, 1885. The Old Warwick League, a men's social and intellectual improvement association, was housed in this building, which is now a private residence at 70 Warwick Neck Avenue. Its library was one of the finest in the state and historian Horace Belcher was the librarian in 1886. Because of the overcrowding of the main school in old Warwick, these students were allowed to have classes at the League Hall. This Queen Anne-style building features an owl carved in a wooden panel over the porch. The original fish-scale and wave-pattern shingles were covered over in the 1970s. (Thomas E. Greene Collection.)

Old Warwick School in 1882. Teacher James T. Lockwood, who later became one of Warwick's longest serving town clerks, is accompanied by his class at the old school, which was demolished in 1886. (Thomas E. Greene Collection.)

Old Warwick School in 1922. Teacher Alice M. Petzka can be seen with her large class at the two-and-a-half-story structure. Built in 1886, this district four schoolhouse, designed by William Walker, is the oldest known school building still standing in Warwick. (Warwick Historical Society Collection.)

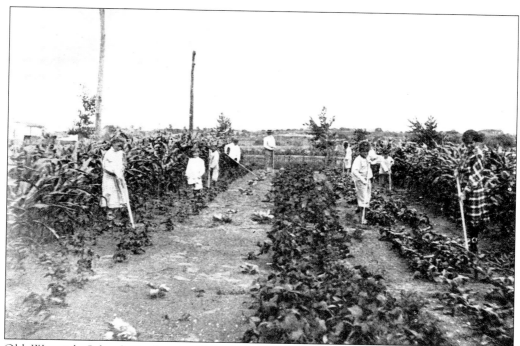

Old Warwick School Garden in 1910. The eastern section of Warwick was primarily an agricultural community in the early twentieth century. Working in the school garden was considered an important part of the educational curriculum. (State Board of Agriculture.)

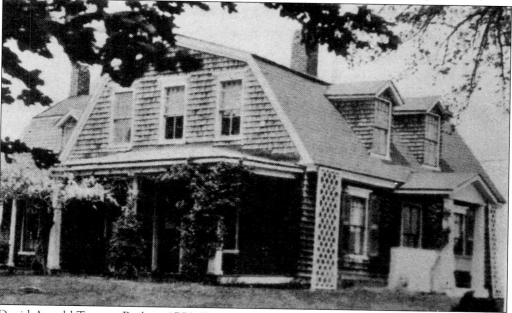

David Arnold Tavern, Built in 1750. British General Richard Prescott was captured and taken to this tavern on the Apponaug-Old Warwick Road (now West Shore Road) in 1777. The tavern was demolished in the mid-twentieth century. (Ernest L. Lockwood, *Episodes in Warwick History*, 1937.)

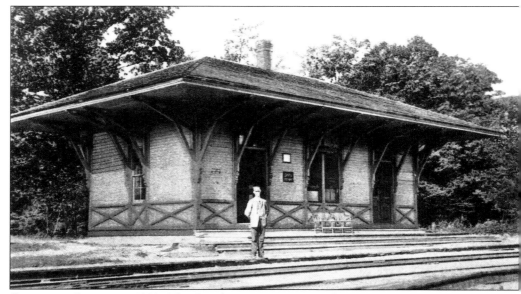

Conimicut Station in 1909. The Beach Avenue section of Conimicut was the center of the village's growth from a summer resort to a year-round suburban area around the turn of the century. The Warwick Railroad became electrified in 1900 which allowed the trolley to make its dramatic impact. (Henry A.L. Brown Collection.)

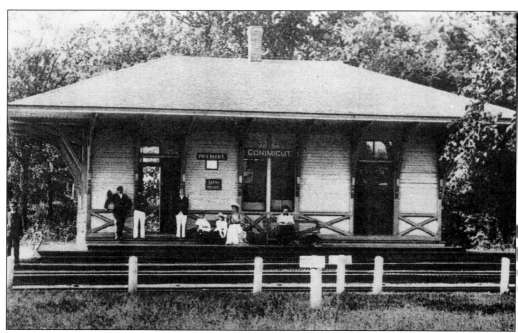

Conimicut Station in 1912. Passengers and friends often met here to await transportation or to catch up on the local news. At this time, the post office was in the station. Later, a separate post office was established between the station and Saint Benedict's Church, as more people made Conimicut their permanent home. (Donald Skuce Collection.)

Woodbury Union Church, c. 1925. Mock weddings were a popular form of entertainment for Sunday school classes at the church. This lovely building on the corner of West Shore Road and Beach Avenue in Conimicut was built in 1907–1908. Prior to the building of the Woodbury Union Church, the Conimicut School was used for religious instruction. The name of the church was selected to honor the Woodbury family (who had donated the land) and also to indicate that the house of worship was inter-denominational. The groom in this ceremony is Armand Truedall and the bride is Hope Collingham. Others identified as being present are Avid Noble, Robert Tinker, and Elwood and Milton Briggs. (Dorothy Andrews Collection.)

The Collingham Family, c. 1913–14. One of the nicest homes in Warwick was owned by the Collingham family. Located at 615 West Shore Road, the house was demolished late in the century and the estate was divided. Included in this family portrait are James H. Collingham, Henry Collingham, Mrs. Henry (Rose) Collingham (with baby Hope on her lap), and Mrs. Elizabeth Green. (Dorothy Andrews Collection.)

Saint Benedict's Church, c. 1930. It was well into the twentieth century before there were enough Catholics in Conimicut to make the building of this church on Beach Avenue possible. (Henry A.L. Brown Collection.)

The Capaldi Home in 1925. Many long-time residents of Conimicut still visit this home at 68 Grace Avenue to recall the old days. Four members of the Capaldi family and Mabel Caproni are shown here enjoying a mid-August day. (Dorothy Andrews Collection.)

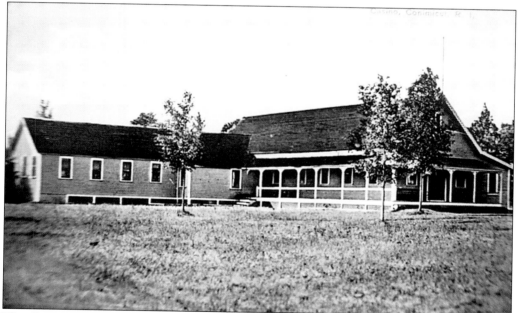

The Conimicut Casino in 1906. The Capaldi home was next to the Conimicut Casino on Grace Avenue. The nostalgia surrounding the casino has lived on long after the building was demolished. For many, the memories of bowling and taking part in other activities at this facility recapture the fun of rainy summer days. (Henry A.L. Brown Collection.)

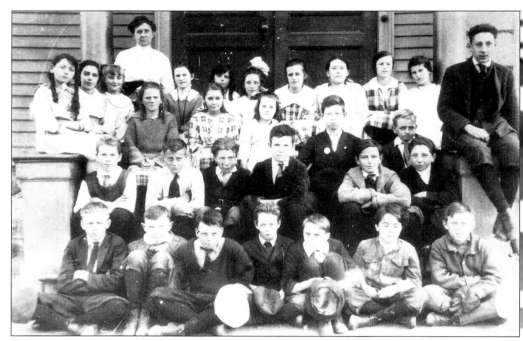

Conimicut School, c. 1919. Nearly all the children in the village went to the Conimicut School, which is now the Ferris Health Center on West Shore Road. The teacher is Mrs. Lane. Vera Dudley, Martha Bowers, Andy Rotelle, and Albert Capaldi are in the class. (Dorothy Andrews Collection.)

Conimicut School, c. 1922. The graduating class of 1922 also included Vera Dudley, Martha Bowers, Andy Rotelle, and Albert Capaldi. The teacher is Anna Monohan. (Dorothy Andrews Collection.)

Conimicut School in 1923. When this picture was taken, this fourth-grade class thought that graduation was so, so long in the future. School days were too long, and summers too short. Eventually, however, the big day came. (Dorothy Andrews Collection.)

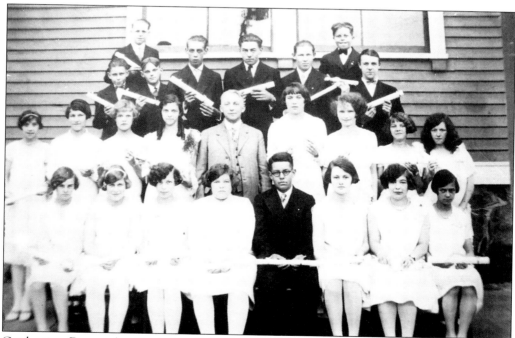

Graduation Day at the Conimicut School in 1927. From left to right are: (front row) Ruth Holdrod, Virginia Jameson, Ethel Follet, Hope Collingham, John Cobb, Ruth Bate, Catharine Lippman, and Helen Hicks; (middle row) Barbara Capaldi, Marguerite Smith, Bernice Nelson, Marion Libby, Mr. Morse, B. Smith, J. Built, Jeanette Haigh, and Helen Morton; (back row) John Cuniff, Robert Davies, John Reynolds, and several other unidentified students of the past. (Dorothy Andrews Collection.)

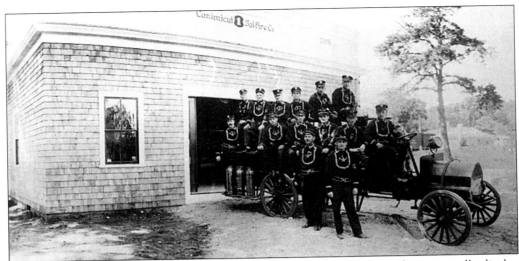

The Conimicut Fire Station in 1916. The volunteers, in their dress uniforms, proudly display their 1910 Chase three-cylinder engine on the Fourth of July. This vehicle, it is believed, was the first motorized piece of firefighting apparatus in Rhode Island. (Greenwood Volunteer Fire Company #1 Museum Collection.)

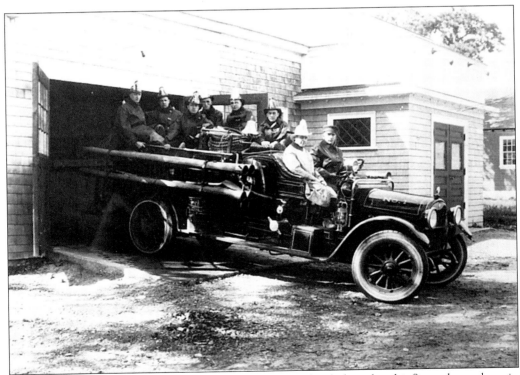

The Conimicut Fire Station in 1924. These volunteers (including the chief) are shown here in full equipment aboard their 1923 Reo Pumper in front of the station on 35 Ardway Avenue. An addition to the old station had been completed by this time. (Greenwood Volunteer Fire Company #1 Museum Collection.)

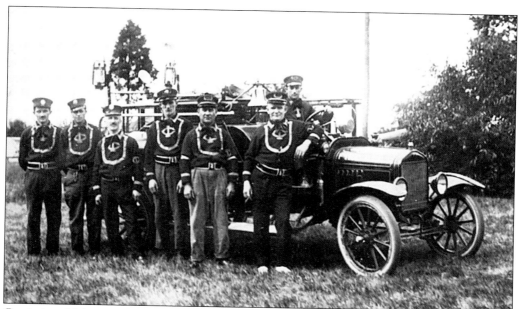

Conimicut Volunteers in 1919. A serious fire in the winter of 1910–11 caused a number of concerned citizens to form the Conimicut Volunteer Fire Department. Thirty-six men responded and selected Arthur W. Coffin to be the first foreman (chief). Some of those early volunteers are shown here with their first chemical truck. (Greenwood Volunteer Fire Company #1 Museum Collection.)

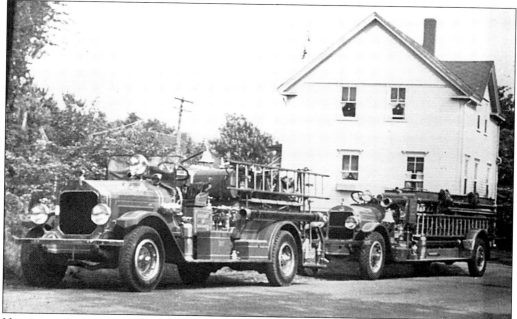

Hurricane Assistance. When the Hurricane of 1938 severely damaged Conimicut, the fire company provided professional and continuous service for twenty-three days. In addition to fighting fires, more than forty-two members of the company assisted in relocating residents to shelter and maintaining order. (Greenwood Volunteer Fire Company #1 Museum Collection.)

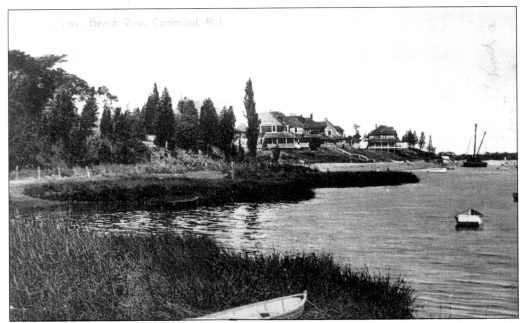

Conimicut Beach, c. 1920. Early in the twentieth century, Conimicut had become a fashionable summer resort. The new, affluent residents insisted on better police and fire protection and helped bring an end to the excesses that were associated with the Mark Rock Hotel. (Donald Skuce Collection.)

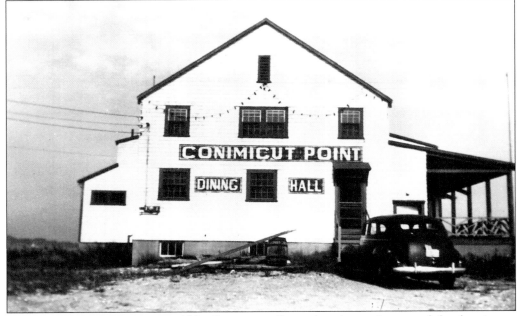

Conimicut Point House, c. 1950. Conimicut Point has been devastated by hurricanes throughout the twentieth century. The Conimicut Point Dining Hall, built to replace the one destroyed by the Hurricane of 1938, was totally demolished by Hurricane Carol in 1954. (Butler Construction Company Collection.)

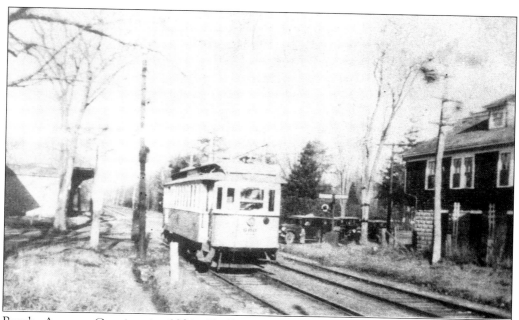

Beach Avenue Crossing in 1934. Trolley #680, a combination passenger and baggage compartment car, is headed towards Buttonwoods. The railroad station, part Henry's Store and Shields Bakery, can be seen in the background. (Dorothy Andrews Collection.)

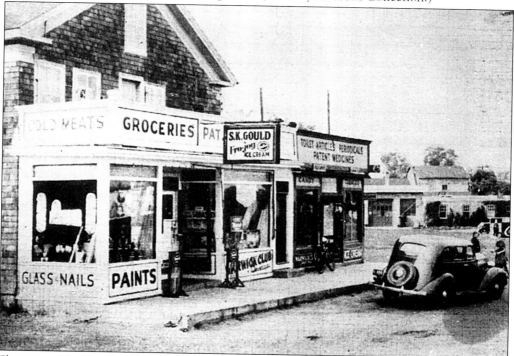

Shawomet Market in 1938. S.K. Gould not only sold all types of groceries, meats, and sundries at his Shawomet market, he also ran a post office here as well. This peaceful scene was observed shortly before the Hurricane of 1938. (George Bastien Collection.)

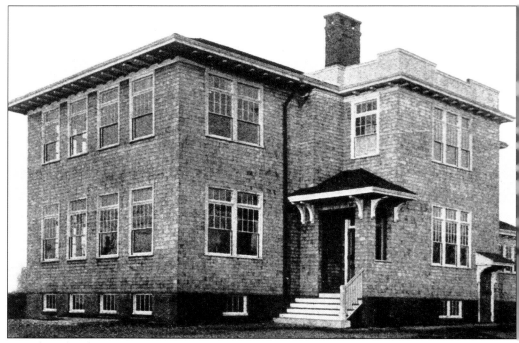

Bayside School in 1914. Bayside was named by Malachi R. Gardiner, a wealthy Providence merchant, who built a summer home there in 1850. The area developed and a number of substantial houses were erected here by the end of the century. The Bayside School was built to meet the needs of the fast-growing community. (Thomas E. Greene Collection.)

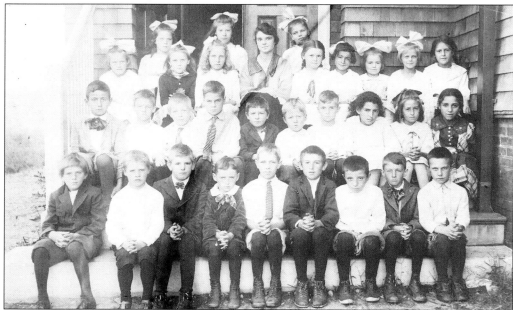

Bayside School in 1915. Among these well-behaved students, all sitting with their hands folded, are Mabel DelPonte (third row, fourth from the right) and Vincent Delponte (second row, first boy on the left). (Mabel DelPonte Collection.)

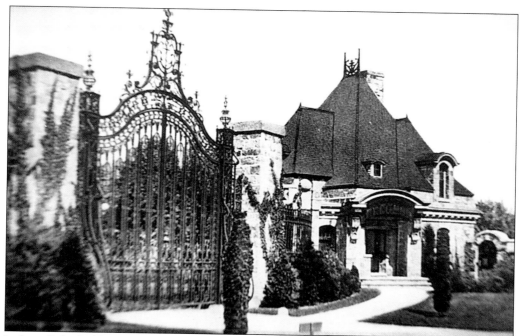

Indian Oaks (Aldrich Estate) in 1915. The ornate gates and gatehouse hint at the opulence of the estate of Senator Nelson W. Aldrich, the man known as the "General Manager of the United States." (Henry A.L. Brown Collection.)

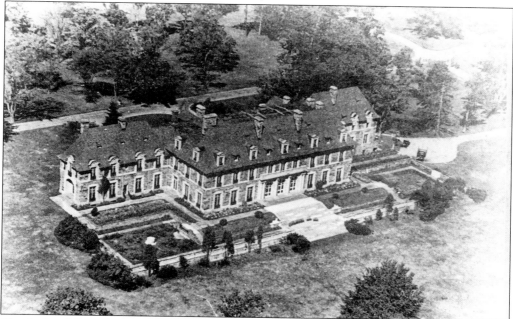

Our Lady of Providence Seminary in 1953. Aldrich's magnificent Indian Oaks property at Warwick Neck was acquired by the Roman Catholic bishop of Providence in 1939 and used as a seminary for many years. The twenty-eight-room mansion, designed as a seventeenth-century French chateau, was completed in 1912. (Reverend Edmund Fitzgerald Collection.)

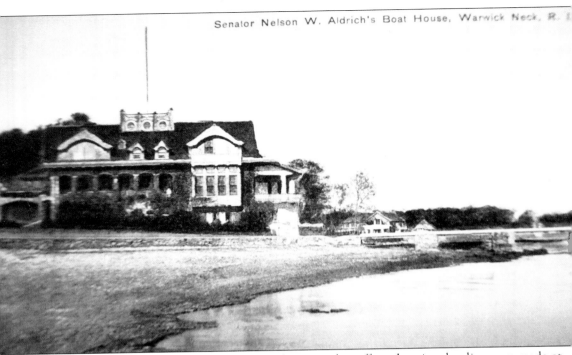

Aldrich Boathouse in 1911. Many major decisions that affected national policy were made at meetings in the Aldrich Boathouse in Warwick. Historians can only guess at the secret dealings and political maneuvering that must have taken place in the upper office that overlooked Narragansett Bay. It was here that "The Four" key senators and President Theodore Roosevelt came to confer with Aldrich. (Henry A.L. Brown Collection.)

ACKNOWLEDGMENTS

This volume has only been possible because of the assistance and generosity of the many who have contributed their photographs and information. Among the very special people who have enriched this book are Henry A.L. Brown and the late Dorothy Mayor. Their vast knowledge of Warwick is only surpassed by their generosity in sharing the material. I would also like to thank Gary Melino and T.D. Brown Studios for preparing and developing the photographs, Bob Champagne for his invaluable help on the Apponaug chapter, Dorothy Capaldi Andrews for her knowledge of Conimicut, and, of course, my wife Jean, for her proofreading, patience, and persistence.